STANLEY SPENCER

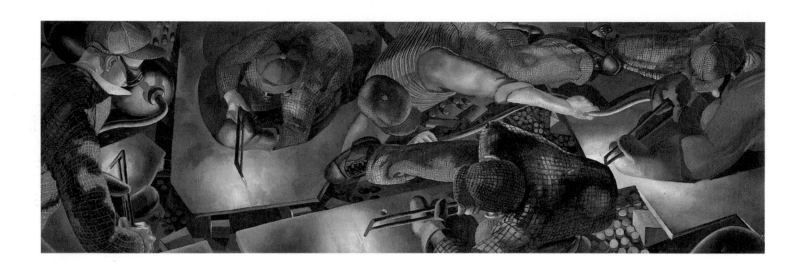

Duncan Robinson

STANLEY
SPENCER

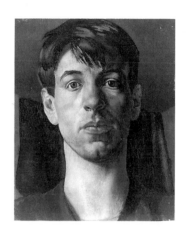

Φ

Acknowledgements

The works of Stanley Spencer are reproduced by permission of the Stanley Spencer Estate.

84, 90 Christie's Colour Library; 27, 28, 29, 31, 32, 36, 37 National Trust Photographic Library; 5, 43, 44, 62, 70, 88 Photo: Royal Academy of Arts, London; 93 Sotheby's; 49 Reproduced by arrangement with Tyne and Wear Museums Service; 82 Yale Centre for British Art, Paul Mellon Fund; 55 Yale University Art Gallery, Anonymous Gift; 52 Collection The Museum of Modern Art, New York. Gift of the Contemporary Art Society, London; 35 National Gallery of Canada, Ottawa. Gift of the Massey Foundation, 1964; 92 Glynn Vivian Art Gallery. Leisure Services Dept., Swansea City Council.

Phaidon Press Limited
140 Kensington Church Street
London W8 4BN

First published 1990
Second edition (paperback) 1993
© Phaidon Press Limited 1990
Text © Duncan Robinson

A CIP catalogue record for this book is available from the British Library

ISBN 0 7148 2810 6

Frontispiece illustrations
Left: *Shipbuilding on the Clyde: Burners* 1940 (Detail). Oil on canvas, triptych, right section, Imperial War Museum, London
Right: *Self-portrait* (1914). Oil on canvas, 63 x 51 cm (24 3/4 x 20 in). Tate Gallery, London

Printed in Singapore

CONTENTS

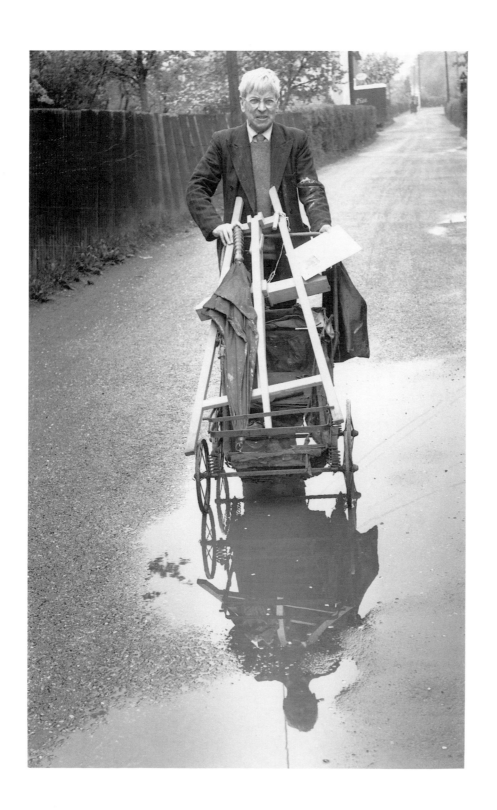

1 A common sight at Cookham.
Stanley Spencer makes his way about
the village with his easel and canvas
on an old pram chassis.

Acknowledgements

This book results from an invitation to revise *Stanley Spencer: Visions from a Berkshire Village*, published in 1979. To Bernard Dod and his colleagues at Phaidon Press, I am grateful for the opportunity to expand the earlier text and to offer what I hope are fresh insights. All of my original debts remain: to the late Richard Carline, Spencer's brother-in-law, who encouraged my first efforts and granted access to family papers. He also contributed to the exhibition I helped to organize for the Arts Council of Great Britain in 1976, as did Antony Gormley and Caroline Leder whose independent researches were summarized in two brief but salutary essays in the catalogue for that show. Essentially, they challenged the prevalent notion of Spencer as an isolated eccentric, by relating both the form and the content of his painting to the period in which he lived. The same theme was taken up four years later by Andrew Causey in 'Stanley Spencer and the Art of his Time', the essay he contributed to *Stanley Spencer, R.A.*, the full retrospective with which the Royal Academy granted posthumous honours in 1980 to one of its more controversial former members. Keith Bell wrote the bulk of that catalogue, which placed Spencer studies on a new plane. My notes attest to the liberal use I have made of what has become an essential work of reference.

My interest in Spencer, which was kindled almost twenty years ago, has been kept alight since in a variety of ways. Today Spencer is more popular than he was during his lifetime, to the point of veneration by a considerable number of artists who have graduated during the last ten years as fervent disciples of figurative painting. It is thanks partly to the new perspectives which they have opened that my own ideas have continued to develop.

Among the individuals to whom I owe longstanding debts, I would like to acknowledge Sir Alan Bowness, Andrew Dempsey, Joanna Drew, Sir Lawrence Gowing, Sophie Gurney, Michael Jaffé, Milo Keynes, Ronald Paulson, Edmund Pillsbury, the late Keith Roberts, Shirin and Unity Spencer and the Trustees of the Stanley Spencer Gallery, Cookham. To Julie Lavorgna, who typed the manuscript and assisted in many other ways, I owe especial thanks.

Duncan Robinson
New Haven, Connecticut, 1989

Foreword

'The last book failed because it was not done by me,' he wrote to his agent Dudley Tooth in 1938. 'I am against a neat book. I would rather it be a confused heap than risk anything being left out.'[1] Spencer seldom approved, let alone appreciated, what was written about him, refusing to recognize 'the second-hand examples I have seen of myself'. By his own admission the statements he made about his art are full of contradictions. Towards the end of his life, overwhelmed by the existence of at least three large, unfinished canvases to which he had attached his highest aspirations as an artist, he expressed his frustration: 'It does not whet my appetite to paint at all,' he admitted in the privacy of a letter he wrote to his first wife, Hilda Spencer, in October 1957, some seven years after her death.[2] To his friends the Rothensteins, Spencer openly declared a similar impatience, although at other times he was equally insistent upon the primacy of painting. In his Introduction to the catalogue of the exhibition of his work at the Tate Gallery in 1955, he allowed that 'the kind of heaven I enter when I do begin to paint I find not at all insipid,' and 'Back to the bottle' seems to have been a favourite phrase he used to describe his addiction.[3]

For Spencer was, first and foremost, a painter. As such, he found drawing indispensable to his artistic process and, as befitted the prize pupil of the Slade School, he became one of the most assured draughtsmen of the twentieth century. Yet drawing remained a means to an end; virtually all of his subject pictures were based upon composition drawings which he squared and transferred to canvas in every detail. Spencer would then paint methodically with fine, sable brushes and ever thinner dilutions of oil paint from one end of his rolled canvas to the other. This led even the most perceptive of his critics, Elizabeth Rothenstein, to argue that 'his creative and vital interests were exhausted by the time he had completed the drawings ... the subsequent act of painting was a craftsman's job.'[4] Fortunately, the paintings themselves counteract that point of view. Spencer drew up his large canvas of *Love on the Moor* [pl. 95] in 1937. For a variety of reasons, he did not begin to paint it until 1949 and he finished it in 1955. Within his personal iconography, this celebration of his first wife as the resident deity of Cookham Moor occupied an especial place. As a result, the picture is one of his most richly resourceful *and* one of his most delicately painted. It is not just the manifest delight with which he invented and peopled this deliciously erotic landscape. In the painstaking treatment of the irregular brick wall which curves along the edge of the meadow behind the revellers there is a devotion to the task of painting which suggests something more than duty. Whether Spencer clambered on to tables or chairs to overcome the limitations of his own stature, or crawled over his canvases spread out on the floor, he 'tickled' them (his word) into life.

Like a good many painters, Spencer used the self-portrait as a yardstick with which to measure himself throughout his career. The man who claimed that 'I don't want to lose sight of myself for

a second' came remarkably close to achieving his ambition in paint. His biographer Maurice Collis argued that out of his interminable writings, with all of their contradictions and prolixities, a portrait of the artist emerges. If it does so, it lacks the clarity and the candour of the visual record. For Spencer the painter scrutinized himself with a rare detachment in each of his seasons, from the Slade to the grave. In the self-portrait of 1914 [frontispiece] the young artist stares out from the canvas with a certain innocent confidence, much as Samuel Palmer had done a century before from his own earthly paradise. The deep shadows of the softly modelled face in the portrait of 1914 are replaced in that of 1936 [pl. 60] by harsh light, bright colour and a strident lack of compromise. The final self-portrait [pl. 99] belongs to 1959, and the weeks immediately before Spencer succumbed to the cancer which dogged the last years of his life. In it, the familiar features are tight-lipped and sombre. The thinnest layer of paint is used to represent the dessicated flesh of a man who recognizes the symptoms of his own physical decay, but who refuses to 'lose sight of (himself) for a second'. Only a painter with a deep-seated instinct for his medium could have used it to express and to expose himself with such painful clarity.

Cookham 1

Stanley Spencer was born in Cookham, Berkshire, on 30 June 1891. According to his younger brother Gilbert, it was, at the time, 'like many Thames-side villages, strongly imbued with a spirit of independence, of a kind which is more usually associated with islands.'[1] During their lifetimes both brothers were to witness a dramatic change in the entire Thames Valley, as railways, and then roads, spread outwards from London to generate the new suburbia. But for Stanley Spencer, Cookham was ever a 'holy suburb of Heaven,' in which the memories of childhood merged with the visions of youth and the fantasies of maturity to inspire an artistic re-creation of the earthly paradise. Spencer's attachment to Cookham was as intense as Samuel Palmer's to Shoreham, and it was sustained to the end of his life.

Spencer was born into a family which, even by Victorian standards, was a large one. His father, William Spencer, advertised himself as 'Professor of Music, Organist of St Nicholas, Hedsor' on the brass plate affixed to the family home Fernlea, in the High Street of Cookham. The eighth surviving child of a peripatetic music teacher who bicycled between lessons and held decided views, above all on education, the young Spencer was taught in an improvised schoolroom set up in a shed at the bottom of the garden by two of his older sisters, Annie and Florence. Life was, in one sense, enclosed. 'There were hidden bits of Cookham,' according to Gilbert Spencer, 'as remote as the Milky Way.'[2] On the other hand, the worlds of music and literature offered an infinite expansion of their horizons. 'Listening to the music was no longer a conscious process; it had become as much a part of our lives as breathing.'[3] With that accompaniment William Spencer, his older children and his pupils conducted the informal education of the two youngest boys and augmented it with readings aloud, chiefly from the Bible. The nursery became their universe; the village churchyard held, somehow, the secret of the Garden of Eden, and Heaven could not be further away than the other side of Widbrook Common. Miracles took place everywhere.

In the late twentieth century it is difficult to appreciate the circumstances of geographical isolation combined with intellectual expansion. But a century earlier they had resulted in William Blake's attempt to 'build a new Jerusalem/in England's green and pleasant land.' For Spencer the distant echoes of the maid's voice, talking in the attic, meant communion with the angels and, when in 1914 he came to paint *The Centurion's Servant* [pl. 12], he naturally went to that very room, under the rafters of Fernlea, to depict the brass bedstead in every detail, filled with the noisy companions of his own childhood. Looking at the picture, all other considerations aside, it is tempting to recall the younger brother's question: 'Stan, what are angels?' The answer: 'Great big white birds ... what pecks.'[4] Spencer never lost that ability to translate the abstract into the reality of experience and to locate the eternal in his own back yard.

2 *The Nativity* (1912). Oil on panel, 102.9 × 152.4 cm (40½ × 60 in). Slade School of Fine Art, University College, London

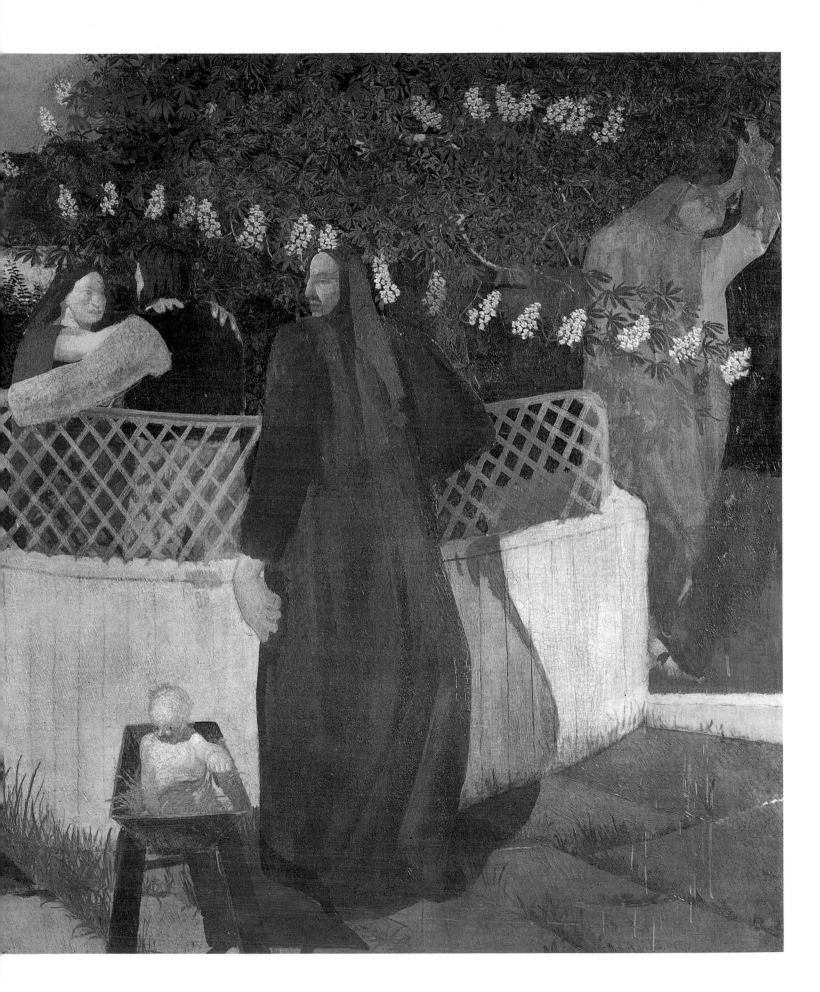

His interest in art, shared by his younger brother, was something of an innovation in a family of musical talents (even Annie practised the violin after putting her brothers to bed). In due course Stanley and Gilbert Spencer got to know William Bailey, a local amateur painter whose daughter Dorothy gave them their first lessons. From these tentative steps Spencer graduated, at the age of sixteen, to the Technical Institute in Maidenhead, three miles from Cookham. There he received his first formal training, and William Spencer took his son's abilities sufficiently seriously to seek both advice and support. It was Lady Boston, sometime student at the Slade, who responded to the appeal and recommended Stanley Spencer to her former school with an offer to pay the fees if he was admitted. He was, in spite of the fact that he failed the general knowledge paper, and he rewarded his patron a year later by winning a scholarship.

At the Slade School Stanley Spencer was dubbed, by his fellow students, 'Cookham.' He remained the incurable day student, who travelled up to London each day by the 8.50 train and returned again to Cookham on the 5.08 p.m. Yet the impact of his training cannot be overestimated; he joined the pre-eminent art school in England in which sound draughtsmanship was, under the tutelage of Henry Tonks, the first priority. He joined a class which included some of the most remarkable talents of twentieth-century British art: David Bomberg, Mark Gertler, Paul Nash, C. R. W. Nevinson and Edward Wadsworth, and at a time which can only be described, for all of them, as momentous.

Spencer's earliest drawings reveal an unmistakable debt to the century in which he was born, to the angular poses and sharp outlines which the Pre-Raphaelites bequeathed to their successors. *Jacob and Esau* [pl. 4] was one of thirteen subjects drawn by Spencer at the Slade Sketching Club between 1909 and 1912. Like many of these studies, it acknowledges a strong debt to the illustrative tradition which runs from Rossetti and Millais to Arthur Rackham and Walter Crane. According

3 *Scene in Paradise* (1911). Pen and ink, 34 × 40 cm (13½ × 15¾ in). Slade School of Fine Art, University College, London

4 *Jacob and Esau* (1910–11). Pen, pencil and wash, 34.3 × 24.1 cm (13½ × 9½ in). Tate Gallery, London

5 *The Last Day* (*c*. 1909). Pen and wash, 40.6 × 58.4 cm (16 × 23 in). Private collection

to Gilbert Spencer, his brother wished even as a child, presumably on the evidence of book illustration, to be able to draw like Rackham.[5] It was an aspiration which his teachers at the Slade did nothing to discourage. As one fellow student put it, 'Stanley was a very conventional draughtsman in the early days, as we all were, pleased with *detailed* accuracy.'[6] To judge from the drawings themselves, he seems to have followed the lead of his Pre-Raphaelite heroes by turning towards some of their early sources. *Jacob and Esau* hints at the kind of exaggerated realism which is far more pronounced in another Sketching Club subject, the *Scene in Paradise* [pl. 3] of 1911. In the same year Spencer began a drawing of *Melancholia*, based on Dürer's famous engraving, and like the northern mannerists who followed Dürer, he attempted to exploit the dramatic contrasts between light and shade, youth and age, beauty and ugliness. In a much later commentary he explained that 'I made the central theme of this composition a clothes horse, which was a sort of house I liked being in when it was standing round the kitchen fire, and in front was a mother holding a baby, who was reaching out and taking hold of the long hair of two bearded old men who are reading Bibles. On the left, there is a nude standing. It is significant to me that I have tried to bring the three experiences of my life together, quite unconsciously, namely the Slade with the life drawing (the nude is just a model), the life at home, and the feeling the Bible gave me.'[7] Too many of Spencer's retrospective statements are misleading in their simplicity; his words disguise the force in a drawing such as this one of distortion and caricature, the eerie juxtapositions of figures and the unmistakable but ambiguous references to the Old and the New Testaments.

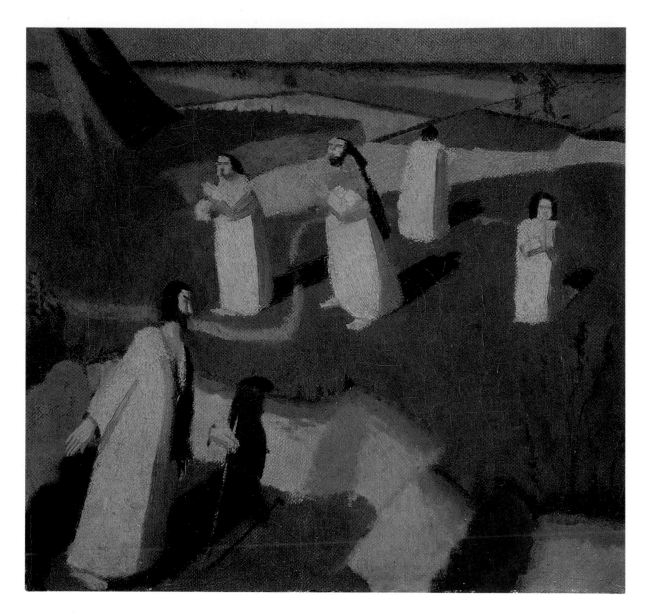

6 *John Donne Arriving in Heaven* (1911).
Oil on canvas, 36.8 × 40.6 cm (14½ × 16 in).
Private collection (on loan to the
Royal Albert Memorial Museum,
Exeter)

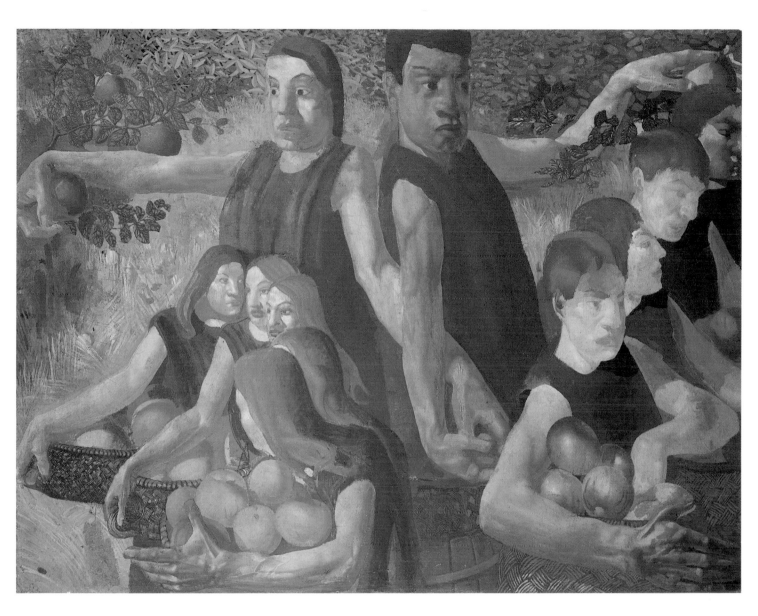

7 *The Apple Gatherers* (1912–13).
Oil on canvas, 71.5 × 92.5 cm (28 × 36¼ in).
Tate Gallery, London

In 1910 Paul Nash joined the Slade School. An established admirer of William Blake (whose fortunes were revived in part by the high regard in which his work was held by the Pre-Raphaelites[8]), Nash's landscape drawings such as *Bird Garden* of 1911 [pl. 8] hint, in his own words, at that 'love of the monstrous and the magical [which] led me beyond the confines of natural appearances.' They also find a reflection in another of Spencer's Slade subjects, the drawing he made in 1911 to illustrate Ecclesiastes 12:5: '... man goeth to his long home.' [pl. 9]

Both Spencer and Nash associated at the Slade with Mark Gertler and the group of young artists who identified themselves from 1911 onwards as the Neo-Primitives. There was also Jacques Raverat and his future wife, Gwen Darwin, who reinforced Spencer's taste for the historically pre-Raphaelite painters of the fourteenth and fifteenth centuries when they gave him a copy of John Ruskin's essay, *Giotto and His Works at Padua*. Spencer was familiar with Ruskin from his father's readings and recitations. He could not fail to respond to the claim that 'Giotto was to his contemporaries precisely what Millais is to *his* contemporaries, a daring naturalist, in defiance of tradition, idealism and formalism. The Giottesque movement in the fourteenth, and the Pre-Raphaelite movement in the nineteenth centuries, are precisely similar in bearing and meaning: both being the protests of vitality against mortality, of spirit against letter, and of truth against tradition.'[9]

As he read on, Spencer's mental images were formed not so much by the black-and-white woodcut illustrations commissioned by the Arundel Society as by the vivid descriptions provided by Giotto's modern champion. When he drew his own illustration of *Joachim among the Shepherds* [pl. 13], he represented those 'plain, masculine kind of people,' identified by Ruskin in the Arena Chapel. Of Giotto's actual technique, he learned that 'even in his smallest tempera pictures, the touch is bold and somewhat heavy. ... Giotto melted all these folds into broad masses of colour ... the dresses are painted sternly,' as they are in the small painting by Spencer of 1911, *John Donne Arriving in Heaven* [pl. 6]. Once again, the immediate stimulus came from a book, this time of *Sermons* by the seventeenth-century poet and divine, another gift from the Raverats. Spencer explained the picture as an attempt to visualize Donne's notion of 'going to Heaven by Heaven.' His brother Gilbert Spencer added that 'he had the idea that Heaven was to one side: walking along the road he turned his head and looked into Heaven, in this case a part of Widbrook Common.'[10] The austere simplicity of this small canvas is unusual. It is worth recalling, once again, Ruskin's account of Giotto's frescoes: 'independent of all the inferior sources of pictorial interest. They never show the slightest attempt at imitative realisation: they are simple suggestions of ideas, claiming no regard except for the inherent value of the thoughts.'

Spencer painted *John Donne Arriving in Heaven* in Cookham, and then took the picture up to London to be criticized by Professor Tonks in one of his composition classes. The verdict was unfavourable; in a letter to his brother Sydney, Spencer quoted his teacher: '"It has no colour, and is influenced by a certain party exhibiting at the Grafton Gallery a little while ago" – the damned liar!'[11] In spite of the painter's reaction, Tonks was merely the first to point out a connection between this and the ferment caused, in 1910, by 'Old Masters of the New Movement,' the first of two exhibitions which the critic Roger Fry organized at the Grafton Gallery, to campaign in England for those Post-Impressionist painters whose work was known only to a small group of artists and collectors. As Fry brought to London significant numbers of paintings by Cézanne, van Gogh and Gauguin, controversy disturbed the classrooms and studios of the Slade. It was, as Paul Nash recalled, 'then seething

8 Paul Nash (1889–1946), *Bird Garden* (1911). Watercolour, ink and chalk, 38.7 × 33.5 cm (15½ × 13½ in). National Museum of Wales, Cardiff

under the influence of Post-Impressionism. ... The professors did not like it at all. The students were by no means a docile crowd and the virus of the new art was working in them uncomfortably. ... Eventually, Tonks made one of his speeches and appealed, in so many words, to our sporting instincts. He could not, he pointed out, prevent our visiting the Grafton Galleries; he could only warn us and say how very much better pleased he would be if we did not risk contamination but stayed away.'[12]

Two years later the second Post-Impressionist exhibition contained an English section, selected by Fry's close friend and collaborator, Clive Bell. It is not difficult to see why *John Donne Arriving in Heaven* was included. The champions of the avant-garde saw a tendency towards abstraction in Spencer's simplified, slab-like figures: an affinity with Paris rather than Padua. Briefly Spencer's vision coincided with that of his fellow students like David Bomberg, whose *Island of Joy* of *c.* 1912 heralded a period of thorough-going geometrical abstraction. But for Spencer the figure itself remained essential.

In 1912 he made a first study for *The Nativity*, the set subject for the Slade's Summer Competition that year. His canvas, more than sixty inches wide, was painted in Ovey's Barn in Cookham; from there he took it up to London to capture the coveted Melville Nettleship Prize [pl. 2]. This time Tonks's reaction was one of generous praise. 'He has shown signs,' he wrote, 'of having the most original mind of anyone we have had at the Slade and he combines it with great powers of draughtsmanship.'[13] In many ways the picture represented a statement of artistic faith. The subject is biblical of course, and the setting is Cookham (Mill Lane, specifically). There is a Pre-Raphaelite concern for the details of nature, manifest especially in the painting, leaf by leaf, of the boughs of the horse-chestnut tree, illuminated by its own, botanically accurate 'candles.' Like Giotto's frescoes, the narrative is compressed to include both salutation and adoration, and in the foreground, with its distance between the kneeling Virgin and her heavenly child, there are echoes of those fifteenth-century altar-pieces which Spencer knew from his visits to the National Gallery in London: Piero della Francesca's *Nativity*, above all. Finally, there are the Neo-Primitive elements in the painting which attest to Spencer's modernity. The frozen poses of the figures and their mask-like faces evoke Gauguin. The composition itself, divided horizontally by means of the board and lattice fence, recalls certain of Gauguin's Breton paintings of *c.* 1889: *Bonjour Monsieur Gauguin* and *Little Girl Keeping Pigs*, for instance. Of all of Roger Fry's Post-Impressionists, Gauguin must have struck the most vibrant chord for the young Spencer. For Gauguin also painted *Vision after the Sermon*[14] and situated the Crucifixion in Pont-Aven, with the Colline Sainte-Marguerite visible in the background,[15] just as Spencer's Cookham served as the natural setting for episodes from the sacred legend, from Creation to Apocalypse.

The Apple Gatherers [pl. 7] derived from a Slade Sketching Club subject and obtained for Spencer, as a fourth-year student, yet another prize. It too evidences his interest in Gauguin, which was reinforced by his friendship with the painter Henry Lamb. Six years older than Spencer, Lamb was the more established of the two; a founder member of the Camden Town Group, he had spent several months during 1910–11 in Brittany, where he steeped himself in the lingering aura of Gauguin and the Pont-Aven school. The debt is clear in paintings such as *Fisherfolk* of 1913 [pl. 10] in which Lamb's diagonal arrangement of impassive heads in profile offers a striking parallel with the younger *Apple Gatherers* in Spencer's canvas. Lamb arranged to buy Spencer's painting but surrendered his prior claim to (Sir) Edward Marsh, whom he recognised not only as a discerning collector but, with remark-

9 *Man Goeth to his Long Home* (1911). Pencil, pen and wash, 43 × 31.8 cm (17 × 12½ in). Tate Gallery, London

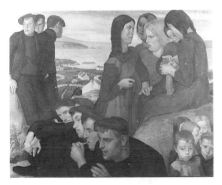

10 Henry Lamb (1883–1960), *Fisherfolk, Gola Island* (1913). Oil on canvas, 82.1 × 102.6 cm (32¾ × 41 in). Private collection

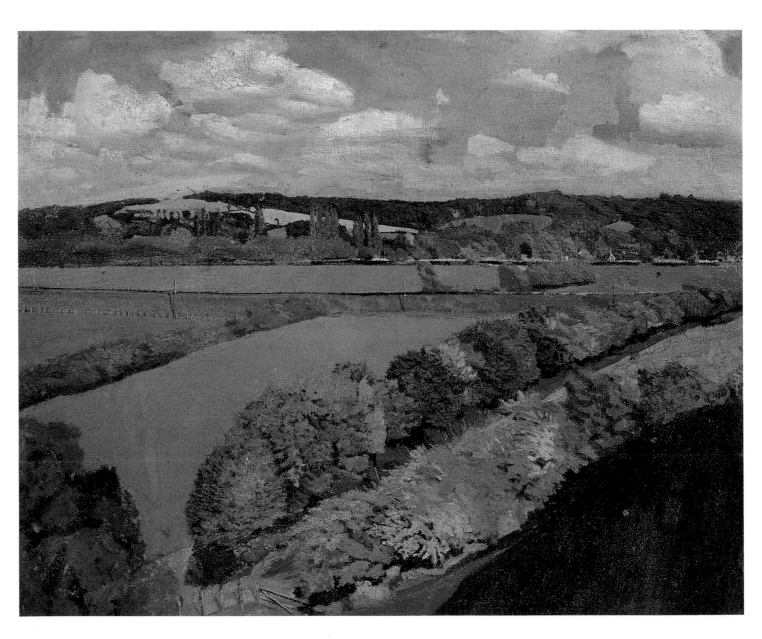

11 *Cookham* (1914).
Oil on canvas, 45.1 × 54.6 cm (17¾ × 21½ in).
Carlisle Museums and Art Gallery

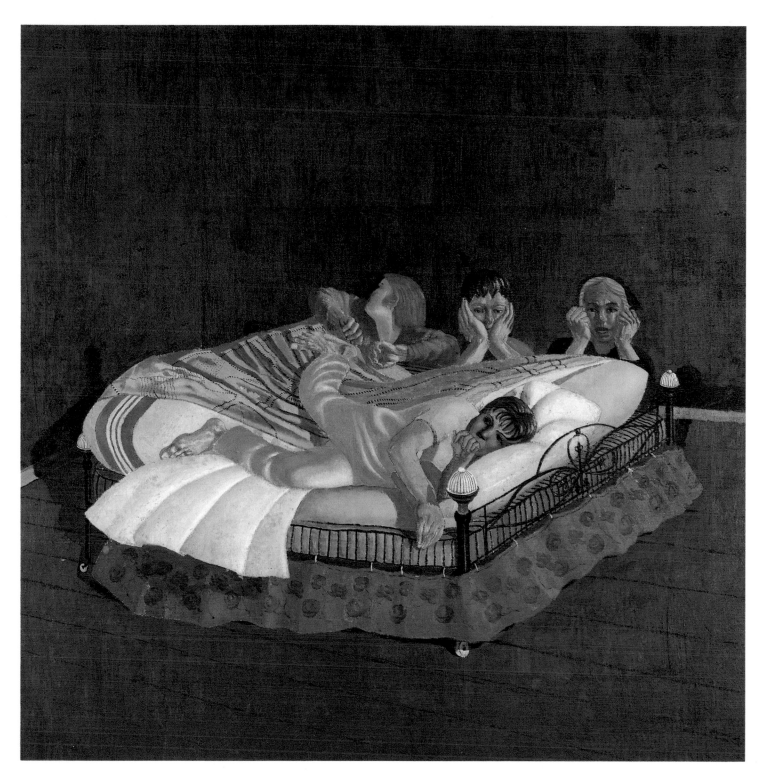

12 *The Centurion's Servant* (1914).
Oil on canvas, 114.5 × 114.5 cm (45 × 45 in).
Tate Gallery, London

able altruism, as an important potential patron for his fellow painter. Instead he contented himself with *The Centurion's Servant* [pl. 12].

When Spencer left the Slade School, it was not a matter of returning to Cookham; he had never really abandoned the place. He seems to have settled into a familiar routine of life at Fernlea and painting in a succession of makeshift studios which he and his brother Gilbert found in barns and sheds around the village. Spencer's artistic agenda was clear; in 1909 he had drawn the second coming of Christ over Cliveden Woods [pl. 5]; in 1912 he had succeeded in bringing *The Nativity* home to Cookham, in triumph. Thanks to his upbringing, he knew the Bible, and the Sketching Club at the Slade had accustomed him to the challenge of depicting its subjects. In Ruskin's account of Giotto's Arena Chapel, with its cycle of frescoes treating the lives of the Virgin and Christ in

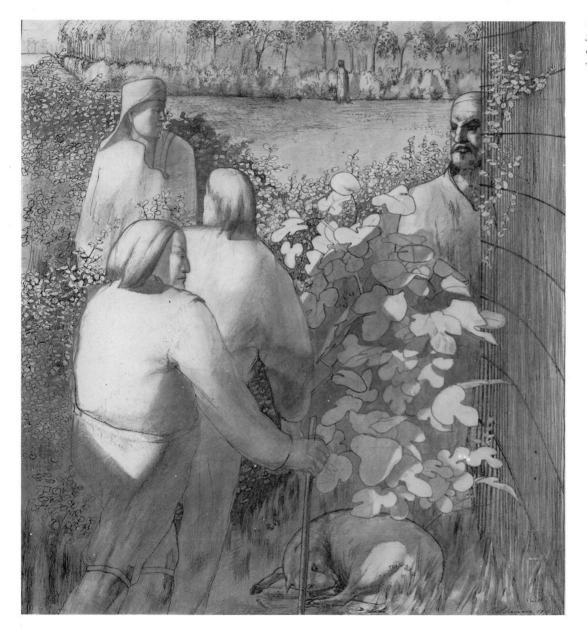

13 Study for *Joachim among the Shepherds* (1912). Pen, pencil and wash, 40.5 × 37 cm (16 × 14¾ in). Tate Gallery, London

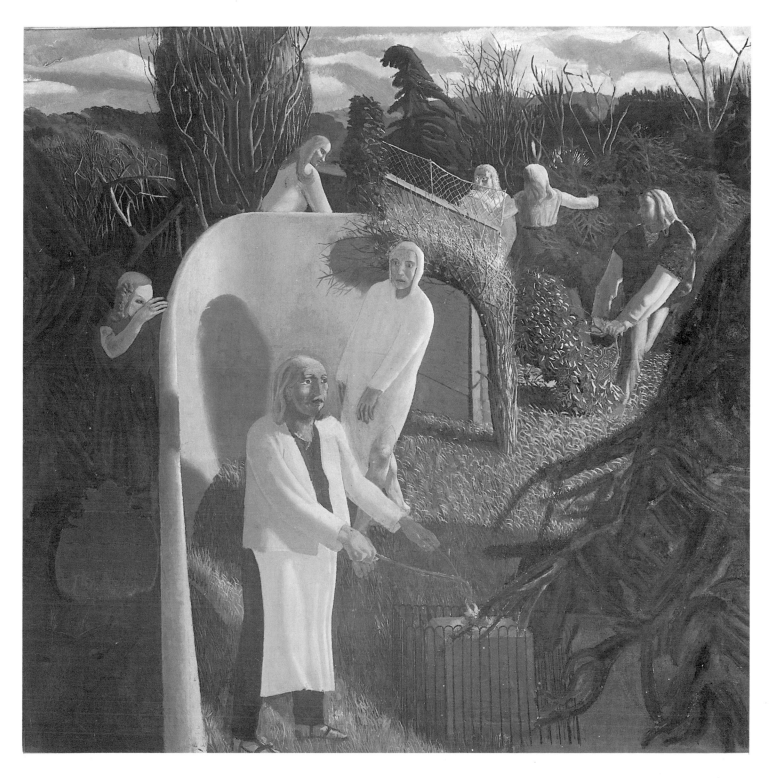

14 *Zacharias and Elizabeth* (1914).
Oil on canvas, 152.4 × 152.4 cm (60 × 60 in).
Private collection

intimate, human detail, he had discovered a programme which he could adapt to his own purposes. Ruskin's analysis can only have confirmed him; 'it was not by greater learning, not by the discovery of new theories of art, not by greater taste, not by "ideal" principles of selection, that [Giotto] became the head of the progressive schools of Italy. It was simply by being interested in what was going on around him, by substituting the gestures of living men for conventional attitudes, and portraits of living men for conventional faces, and incidents of every-day life for conventional circumstances, that he became great.'[16]

In *The Visitation*, of 1912–13, Elizabeth and Mary are represented by 'Dot' Wooster, the butcher's daughter, and Peggy Hatch, a milkmaid who was a cousin of the Spencers. Painted in the old schoolroom at the bottom of the garden, the view through the door is an actual one of backyard trees and outbuildings. A year later Spencer painted *Zacharias and Elizabeth* [pl. 14], set in another local garden, as 'an attempt to raise that life round me to what I felt was its true status, meaning and purpose. A version of the St Luke passage, the gardener dragging the branch of ivy, and Mrs Gooden giving me permission to walk about the garden of the untenanted St George's Lodge ... the whole of what I hoped was dependent on the reality of everyday life.'[17]

At the age of twenty-two Spencer had not only completed his formal art education with flying colours, he had done so as 'Cookham.' Somehow he had gained experience without the sacrifice of that essential innocence which was fundamental to his art. In 1914 he painted one of his first 'pure' landscapes [pl. 11], an exercise in naturalism in which 'everything seemed fresh and to belong to the morning.'[18] It too was bought by Marsh. As the list of his patrons grew, the holy suburb was invaded with increasing frequency, until the archpriestess of metropolitan culture, Lady Ottoline Morrell, paid 'Cookham' the ultimate compliment of travelling in a London taxi to the doorstep of Fernlea. By all accounts Spencer was less impressed than the rest of the family. Nothing, it seemed, could distract him from the course he had chosen. As Ruskin wrote of Giotto, 'apart from all reference to the legends, there is something peculiarly beautiful in the simplicity of [his] conception ..., as though believing that angels might appear anywhere, and any day, and to all men, as a matter of course, if we could ask them.'[19] For Spencer, too, the natural and the supernatural commingled. In a long letter which he wrote from the battle front in 1917, he used the present tense to recapture not so much a vision of his youth as his youthful experiences, in which visions were taken for granted: 'We all go down to Odney Weir for a bathe and a swim. I feel fresh, awake and alive; this is the time for visitations. ... I swim right in the pathway of sunlight; I go home thinking of the beautiful wholeness of the day. During the morning I am visited and walk about in that visitation. ... In the afternoon I set out my work and begin the picture. I leave off at dusk feeling delighted with the spiritual work I have done.'[20]

War

'When I left the Slade and went back to Cookham, I entered a kind of earthly paradise. Everything seemed fresh and to belong to the morning. My ideas were beginning to unfold in fine order when along comes the war and smashes everything.'[1]

In July 1915, Spencer enlisted in the Royal Army Medical Corps. He was sent initially to the Beaufort War Hospital, a home for the mentally retarded near Bristol, which had been requisitioned for military use. After nine months there, he signed up for overseas service, and in August 1916, he was assigned as an orderly to the 68th Field Ambulances in Macedonia. In between bouts of duty, carrying the wounded to field stations behind the lines, he found enough leisure to read widely, from *Paradise Lost* and the plays of Shakespeare to the poetry of Blake and Keats and the novels of Dostoevsky. In letters to his sister Florence, the young soldier described his literary experiences alongside his military ones. 'I do not pine for anything now that I have got Shakespeare. He beats the best bread ever baked.'[2] Not that Florence Spencer's food parcels were scorned: 'so very hungry between meals out on these hills that I could eat a hayrick.'[3] In Greece Spencer contracted malaria but, after several weeks in hospital, returned to the Field Ambulances. Then, in August 1917, he volunteered once again, this time to join a fighting unit, the 7th Battalion of the regiment named for his home county, the Royal Berkshires. 'It is very nice to be with the Berkshire boys,'[4] he wrote to Florence, in spite of the fact that for Spencer the last six months of the war were by far the most dangerous.

The Berkshires held a section of the front line which was advanced that summer against the Bulgarian army. During the offensive there was no relief for Spencer's unit or for Spencer personally, although a letter reached him from his friend Gwen Raverat with news of his appointment as a war artist. This resulted from the efforts of Muirhead Bone, doyen of the Official War Artists, seconded by Spencer's influential patron Edward Marsh and by his former Slade Professor, Henry Tonks. All three were anxious to rescue the young artist they admired from the fate which had overtaken his brother Sydney,[5] but without specific orders from the War Office, a front line regiment could not and would not withdraw a man from the ranks. So Spencer soldiered on, until a recurrence of malaria returned him at the end of September to a hospital at base. Once the armistice was declared, he was invalided out of Macedonia and returned overland to England. By December Private Spencer was back in Cookham, on leave pending demobilization, and with a commission from the Ministry of Information to paint a picture based upon his wartime experiences.

Travoys with Wounded Soldiers Arriving at a Dressing Station at Smol, Macedonia [pl. 15] recalls in vivid detail one amongst the many experiences of the medical orderly. With characteristic precision Spencer identified the picture with a particular night in September 1916, following an attack by

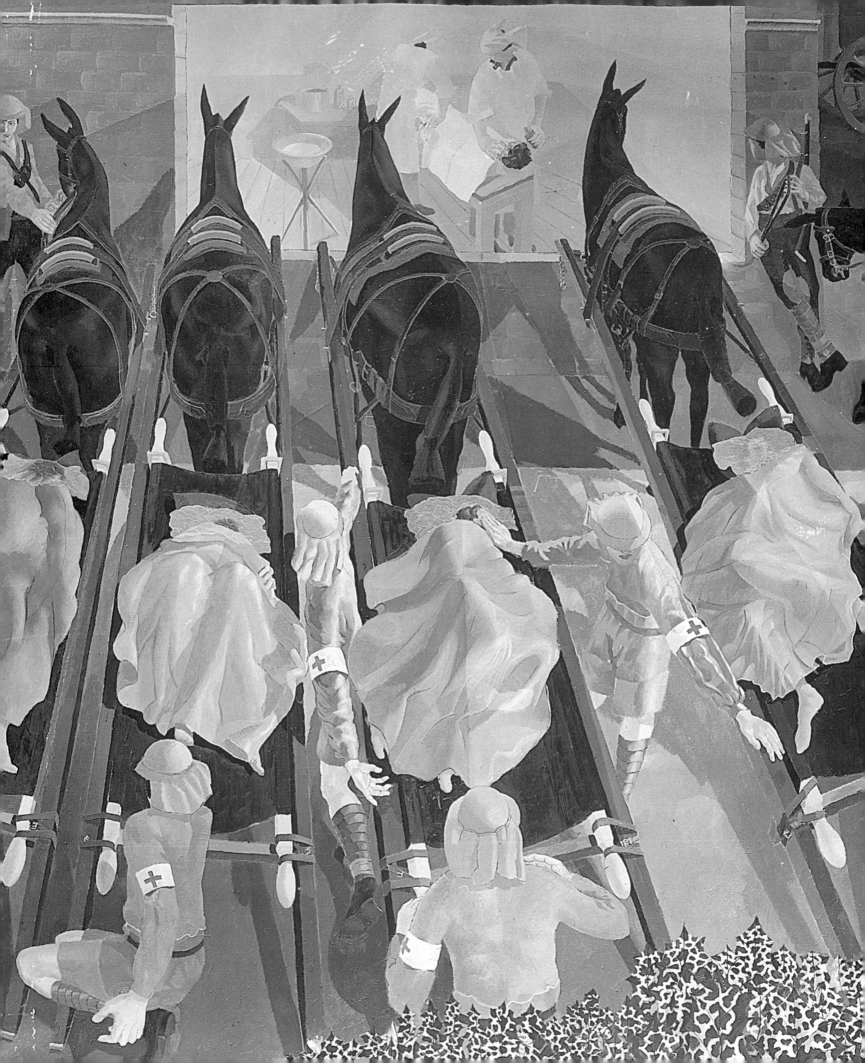

the 22nd Division on Machine Gun Hill in the Dorian–Vardar sector of the battlefield: 'I was standing a little way from the old Greek church, which was used as a dressing station and operating theatre, and coming there were rows of travoys and limbers crammed full of wounded men. One would have thought that the scene was a sordid one, a terrible scene ... but I felt there was a grandeur ... all those wounded men were calm and at peace with everything, so that pain seemed a small thing with them. I felt there was a spiritual ascendancy over everything.'[6] In the painting the fan-like arrangement of the stretchers imposes a decorous order upon the painful reality of the scene, as men and mules face reverently inwards, towards the focal point of the composition, the brightly lit operating theatre which appears as a kind of altarpiece within the hastily transformed interior of the church. All of the sketches Spencer made soon after the event were lost at the front. Back in Cookham, he began all over again to re-create the experience from that phenomenal memory for detail which never deserted him, in spite of a growing conviction, after the war, that he had lost the freshness of his youthful antelapsarian vision.

To that only Cookham gave access. Upstairs in Fernlea Spencer found the unfinished canvas of *Swan Upping* [pl. 16], begun in 1915 after he conceived the idea for the picture 'as I sat in our north aisle pew' in church one Sunday morning.[7] He wanted, as he explained later, to take 'the in-church feeling out of church.' To do so, he simply transferred his act of worship to the secular ritual performed annually by order of the Companies of Vintners and Dyers, owners, with the crown, under a time-honoured royal licence of the swans on the River Thames. Spencer duly completed *Swan Upping* before embarking upon a series of canvases designed to reaffirm his faith in his birthplace as the new Jerusalem. In each of these the events of Holy Week are brought home to Cookham.

The Last Supper [pl. 23] was based upon drawings made in 1915 and revised in 1920. The painter chose as his setting a local malt-house where he relished a sense of seclusion which was reinforced by the unusual effect of daylight slanting across the empty space from windows set low in the façade of the building. The result in the painting is one of monastic simplicity. The narrative is a composite one which combines the breaking of bread as described in the Synoptic Gospels with details from that according to St John in which the young Evangelist 'was at the table reclining on Jesus' bosom.'[8] Spencer's emphasis upon the disciples' feet may also derive from St John's gospel, in which the account of the Last Supper begins with Christ's ceremonial washing of them. The composition is as taut as the scene is tense; the disciples are united by the repetition of their poses and the sharp rhythms of their draperies as they sprawl around the steeply foreshortened table. Individuality is confined to their faces, turned towards, as all eyes are rivetted upon, the breaking of bread. No less than before the war, Spencer's efforts recall his admiration for early Italian painting, as well as his knowledge of Post-Impressionism. 'The effect is due,' to adapt Roger Fry's words on Giotto, 'to the increased command ... of simplicity and logical directness of design.'[9]

Spencer's Passion cycle (for that is the sum of the parts) continued with *Christ Carrying the Cross* [pl. 22]. It was one of some twenty canvases painted across the river from Cookham at Bourne End, where Spencer found lodgings with (Sir) Henry Slesser and his wife. Spencer traced the origins of the picture to a newspaper report of the death of Queen Victoria quoted by his host as an example of sensationalist journalism. He also explained the inclusion of two workmen carrying ladders in disarmingly personal terms. One day while he was at work on the composition, he saw Fairchilds the builder's men walking just so past The Nest, the ivy-covered house to the right of Fernlea.[10]

15 *Travoys with Wounded Soldiers Arriving at a Dressing Station at Smol, Macedonia*, detail (1919). Oil on canvas, 182.9 × 218.4 cm (72 × 86 in). Imperial War Museum, London

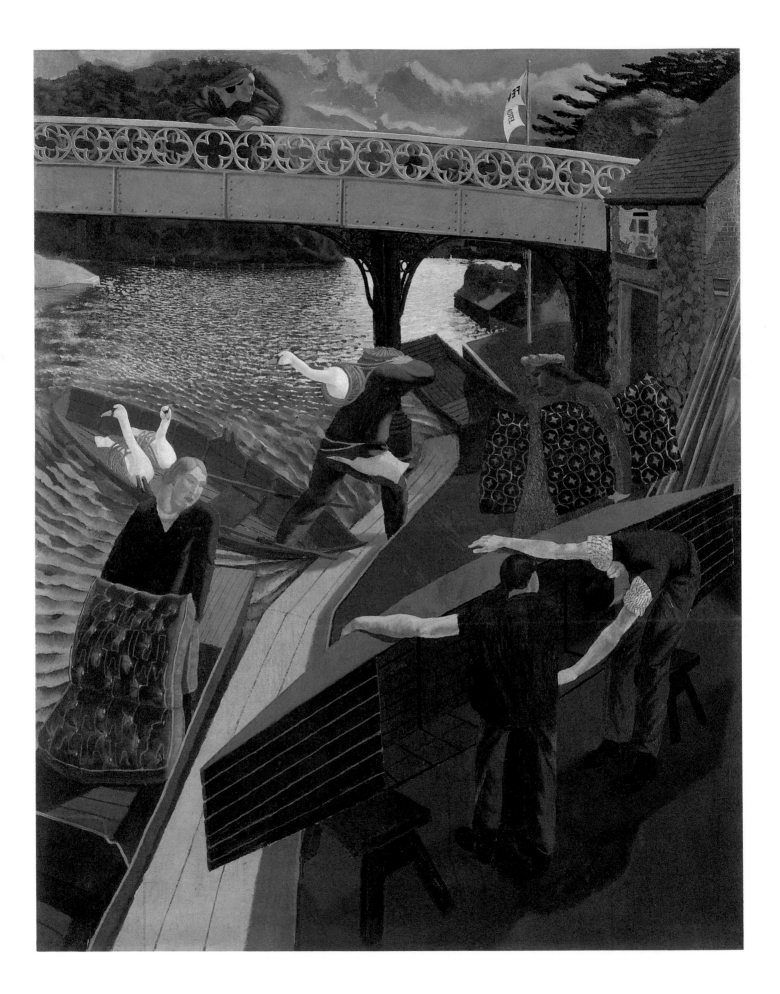

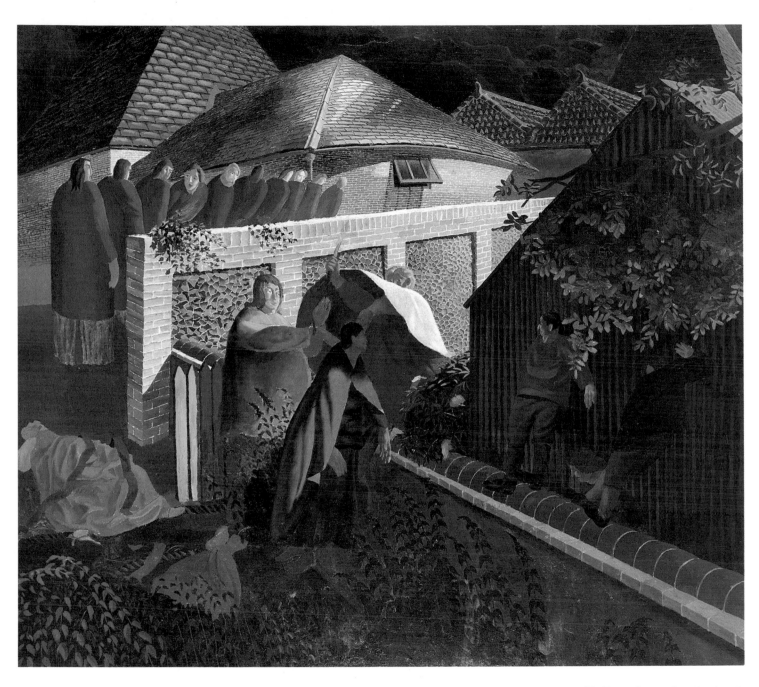

17 *The Betrayal*, second version (1923).
Oil on canvas, 122.7 × 137.2 cm (48 × 54 in).
Ulster Museum, Belfast

16 *Swan Upping at Cookham* (1915–19).
Oil on canvas, 148 × 115.5 cm (58¼ × 45¾ in).
Tate Gallery, London

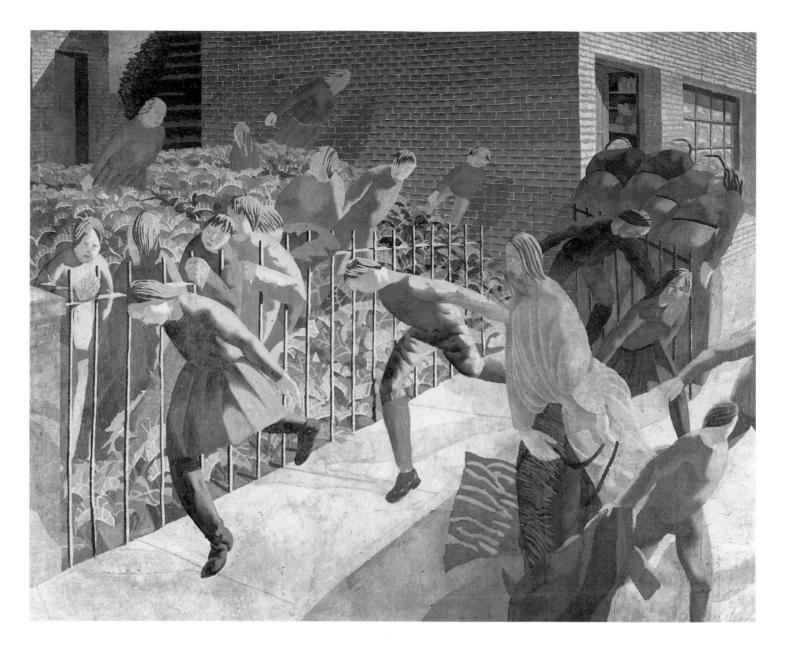

They provided the essential ingredient, 'the reality of everyday life,' which enabled Spencer to locate the *via crucis* in Cookham High Street. Visually, the diagonal formed by the two ladders echoes the shape of the cross itself, supplying an incongruous contrast to the burden carried on Christ's shoulders. Intentionally or not, the ladders also add to the picture another conventional symbol of the Passion, associated with Joseph of Arimathea and the Deposition.

Several months later, Spencer was at work on a companion piece, *Christ's Entry into Jerusalem* [pl. 18]. He first treated the subject in a Slade Sketching Club drawing of 1910 but appears to have been far from satisfied with his efforts in 1921: 'You will be glad to hear that I am painting another dud!' he wrote to his friend Henry Lamb on 14 June; 'As per usual all the lovely light which I got on the people running down the garden is not to be seen in the painting.'[11] As Keith Bell and others have pointed out, the figure of Christ on the donkey, both uncomfortably foreshortened in the lower right corner of the canvas, is strangely subordinate within the composition, which is domi-

18 *Christ's Entry into Jerusalem* (1921). Oil on canvas, 114.3 × 144.7 cm (45 × 57 in). Leeds City Art Galleries

nated by the diagonal footpath along which two children are shown running, intent on staying ahead of the procession.

Two years later, in the painting of *The Betrayal* [pl. 17] the principal figures are restored to the centre of the stage, as Christ restrains his disciple Peter from attacking the servant of the High Priest. Here it is the Spencer brothers who appear voyeuristically on the ridge of the garden wall, as everyday witnesses to the sacred legend. Once again, it goes without saying that Cookham provided the setting: the walled gardens of Fernlea and The Nest with the corrugated iron shed, the schoolroom of Spencer's childhood, on the right of the composition. Beyond, the knapped flints and bricks of the boundary walls and the pantiles of the cottage roofs glisten in the moonlight to provide an eerie and claustrophobic setting for the night scene described in St John's gospel. The broad and busy daylight of *Christ's Entry into Jerusalem* gives way to the unlit garden of Gethsemane. In spite of the nonchalance with which Spencer and his brother look on, the vision is one of childhood fear, of deep shadows filled with insubstantial forms and mysterious action, of familiar places rendered unsafe by the cloak of darkness.

As must be clear, Spencer's Life of Christ did not progress chronologically. He painted a *Crucifixion* [pl. 25], perhaps as a study for a larger canvas, in 1921. He also chose a different setting for the harsh and barren landscape of Calvary. 'The first beginning of the Crucifixion in my mind,' he recalled in 1957, 'was the memory I had of some mountain which was in a range . . . dividing Macedonia

19 *Scrubbing Clothes* (1919). Oil on millboard, 17.8 × 22.9 cm (7 × 9 in). Private collection

20 *Making a Red Cross* (1919). Oil on millboard, 17.8 × 22.9 cm (7 × 9 in). Private collection

21 Henry Lamb (1883–1960), *Irish Troops Surprised by a Turkish Bombardment in the Judaean Hills* (1919). Oil on canvas, 183 × 218.5 cm (73¼ × 87½ in). Imperial War Museum, London

from Bulgaria. I and some Berkshire Regiment men and some Cyprian Greeks were walking over the snow. . . . As I walked towards the range I did not at all think of a Crucifixion, every sound was muffled . . . and only the faint jingle and squeaking of the mules' harnesses. But somehow though some of my worst experiences were ahead of me . . . I felt hopeful.'[12] It is possible that this recourse to wartime experience was stimulated by Spencer's visit to Muirhead Bone, the Official War Artist whose efforts had resulted in the commissioning of *Travoys*. Spencer was staying with the Bones at Byways, their house in Steep, near Petersfield, when he painted the *Crucifixion*. Beyond that, the association of Christ's suffering with his own 'worst experiences' needs little explanation.

What is significant is that even as Spencer attempted to reconstruct his past in postwar Cookham, he began to make a series of pictorial excursions into his still painful memories of the war. Two small oils survive from 1919, sketches of soldiers working under orders but out of danger, behind the lines in Macedonia [pls. 19 and 20]. Both may have been preparatory to further commissions

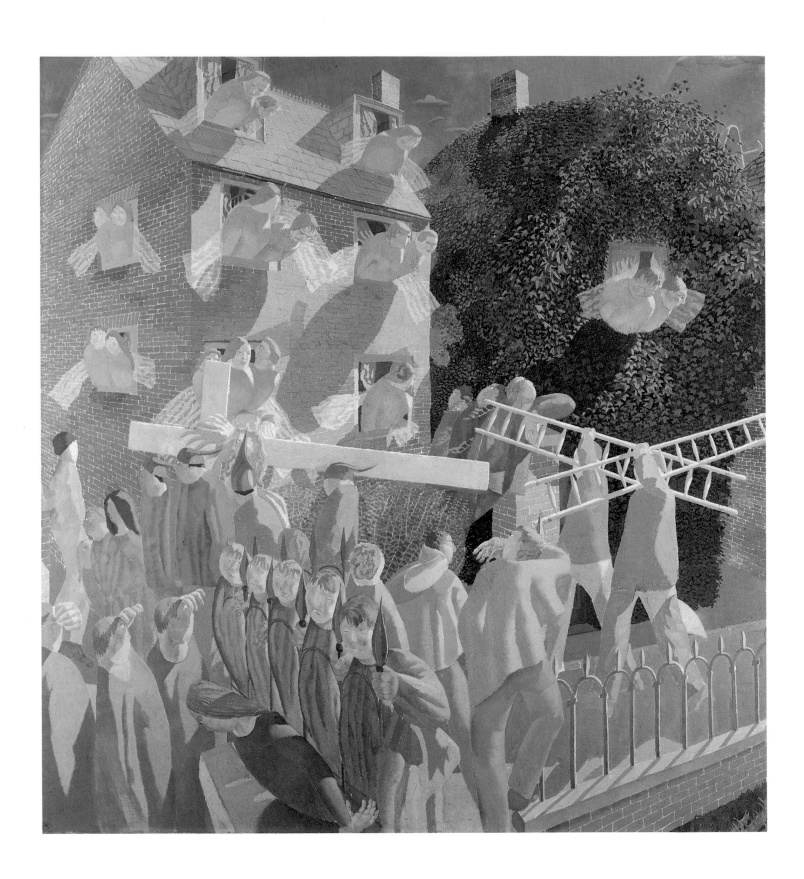

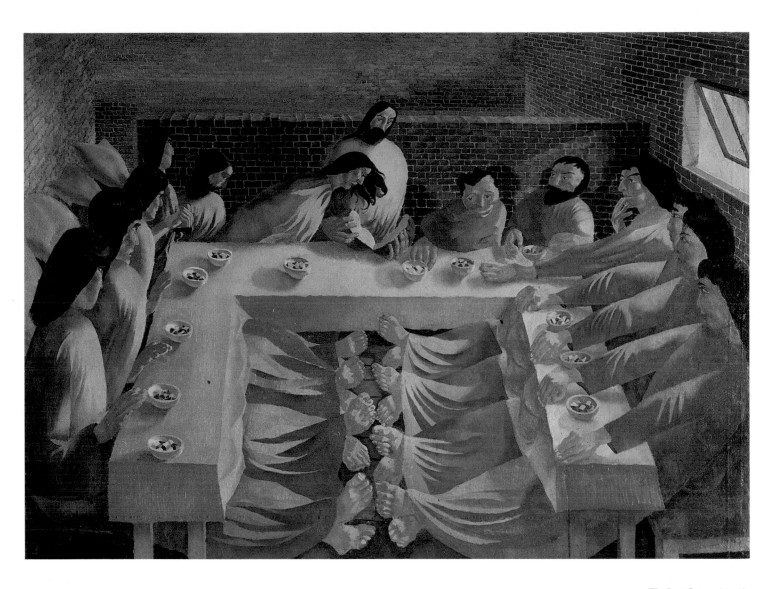

23 *The Last Supper* (1920).
Oil on canvas, 91.5 × 122 cm (36 × 48 in).
Stanley Spencer Gallery, Cookham

22 *Christ Carrying the Cross* (1920).
Oil on canvas, 153 × 143 cm (60¼ × 56¼ in).
Tate Gallery, London

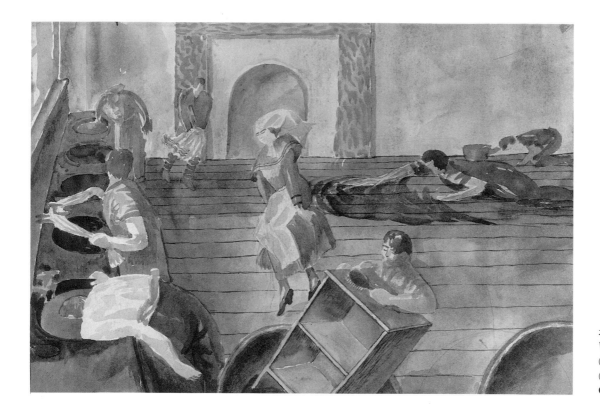

24 *Scrubbing the Floor and Soldiers Washing, Beaufort Hospital, Bristol* (*c.* 1921). 25.4 × 36.5 cm (10 × 14¼ in). Fitzwilliam Museum, Cambridge

Spencer hoped to obtain as an Official War Artist.[13] After relatively modest beginnings during the war, Charles Masterman's adventurous scheme was promoted vigorously by Lord Beaverbrook once he had become Minister of Information in February 1918.[14] In the years immediately following the Armistice, it combined with various other commemorative initiatives to provide work for a large number of painters and sculptors. Artists like Percy Wyndham Lewis and David Bomberg [pl. 33] were obliged to compromise the abstract tendencies of their painting to satisfy the demands of their patrons for the kind of specificity which only representational art could satisfy. Spencer's friend Henry Lamb was also at work, on *Irish Troops Surprised by a Turkish Bombardment in the Judaean Hills* [pl. 21], a canvas which suggests that his attitude towards the men who fought in the Great War was closer to Spencer's than it was to that of the Vorticists. He too adopted a high viewpoint from which to survey a panoramic landscape filled with specific violent incident.

Spencer's prolonged stay at Byways had another, war-related purpose. Anxious to promote the younger artist whose work he continued to admire, Muirhead Bone arranged for Spencer to paint a mural in the Memorial Hall in the village of Steep. The drawing of *Scrubbing the Floor and Soldiers Washing* [pl. 24] was based upon his experiences as a medical orderly in training at the Beaufort War Hospital. It has been identified[15] as one of two studies for the project which was abandoned, by mutual agreement, when it became clear, in December 1921, that after five months with the Bones Spencer had overstayed his welcome.

Rejected by one group of friends, Spencer gravitated towards another. In 1915 he had met the painter Richard Carline [pl. 40]. After the war their friendship resumed, and Spencer became an intimate in the Carline family and circle of artists. The Carlines' house in Hampstead was conveniently

close to Henry Lamb's studio on the top floor of the Vale Hotel in the Vale of Health, which gave further encouragement to Spencer who, in the summer of 1922, accompanied the Carlines on an expedition to Yugoslavia. By then he had declared his interest in Hilda Carline, as well as in the remnants of the Ottoman Empire which prompted the visit.[16] It is also worth noting that less than four years after his return from active service in the eastern Mediterranean, Spencer and his friends made for Sarajevo, the capital city of Bosnia, where the first, fatal shot of the war was fired against the Archduke Francis Ferdinand in August 1914. At Lake Scutari, later in their summer of 1922, the travellers were little more than a hundred miles from the Macedonian hills in which Spencer had fought during the last year of the war. The irony may have been unintentional, but he was to utilize one of his landscape studies, a view of Ragusa painted in 1922, when he came to paint *Driven by the Spirit into the Wilderness* fifteen years later.

Meanwhile, Spencer continued to be driven by his memories of the war. Back in England in June 1923, he went to stay with Henry Lamb at Poole in Dorset. Lamb wrote to Richard Carline, 'Stanley sits at a table all day evolving acres of Salonica and Bristol war compositions.'[17] In spite of his earlier failures to commemorate his war service in paint, the idea of doing so continued to beset him. And by 1923 he had, to quote from one of the letters he wrote to Hilda Carline, 'drawn a whole architectural scheme of the pictures.'

Spencer continued to keep her posted. In July he wrote about the idea he had discussed with Henry Lamb, of raising a subscription among his friends and patrons to pay for a building to house the cycle of war memorial paintings he had designed. Lamb nominated his friend George Kennedy as architect. Spencer's list of potential subscribers included Mr and Mrs J. L. Behrend, owners of *Mending Cowls, Cookham* of 1915 and *Swan Upping* [pl. 16]. They visited Lamb and Spencer in Dorset, and in his letter of 19 July, Spencer explained that 'they greatly admired the war designs. Louie Behrend thought it was the best thing I had ever done.'[18] Back in Hampstead two months later, Spencer was delighted to hear from Lamb that the Behrends were sufficiently impressed to want to underwrite the entire scheme. Mrs Behrend's brother, Lieutenant Henry Willoughby Sandham, R.A.S.C., had died in 1919 as a result of an illness he had contracted on active service in Macedonia. Spencer's project featured his own experiences of that same theatre of war, a tenuous but sufficient link for the Behrends to commission the chapel *in memoriam*, although J. L. Behrend freely admitted that 'without Stanley, poor Hal would have had no memorial.'[19]

Negotiations began at once. Inevitably, Spencer wanted the chapel to be built in Cookham, but the Behrends prevailed with their natural preference for a site near their home in the Hampshire village of Burghclere. The idea of employing George Kennedy as the architect was abandoned in favour of the Behrends' friend Lionel Pearson, who incorporated two almshouses with the plan at their request and followed more faithfully than Kennedy might have done the initial ideas for the interior sketched into Spencer's preliminary designs [pl. 30]. The drawings he made in 1923 for the north and south walls are specific in overall proportions, registers and bay divisions. Even the details of the curved plaster mouldings, corbels and dado are clearly indicated in a design which pays more than a little tribute to the fourteenth-century chapel built in his father's memory by Enrico Scrovegni in Padua and decorated at his behest by Giotto di Bondone. The analogy was pressed by Spencer's future brother-in-law Richard Carline while, according to George Behrend, the painter summed up his own excitement to his patrons in three words: 'What ho, Giotto!'[20] Initially at least,

25 OVERLEAF: *The Crucifixion* (1921). Oil on paper, mounted on canvas, 66.7 × 107.9 cm (26¼ × 42½ in). Aberdeen Art Gallery and Museums

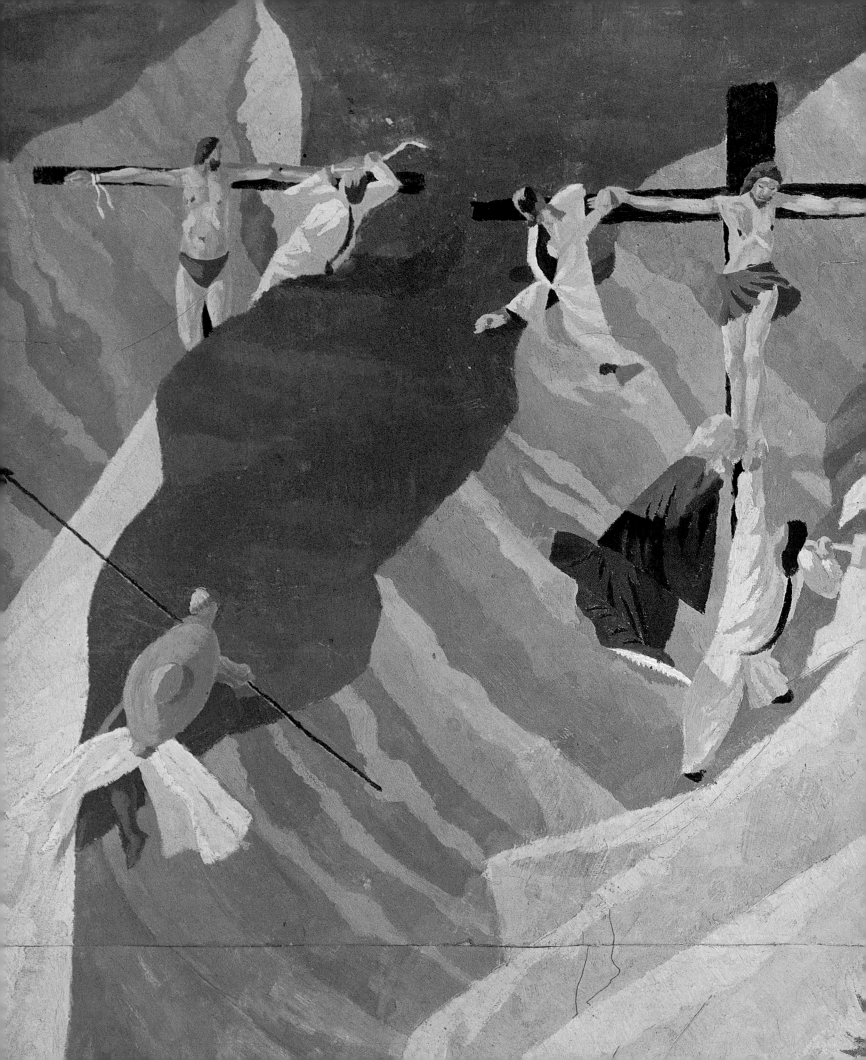

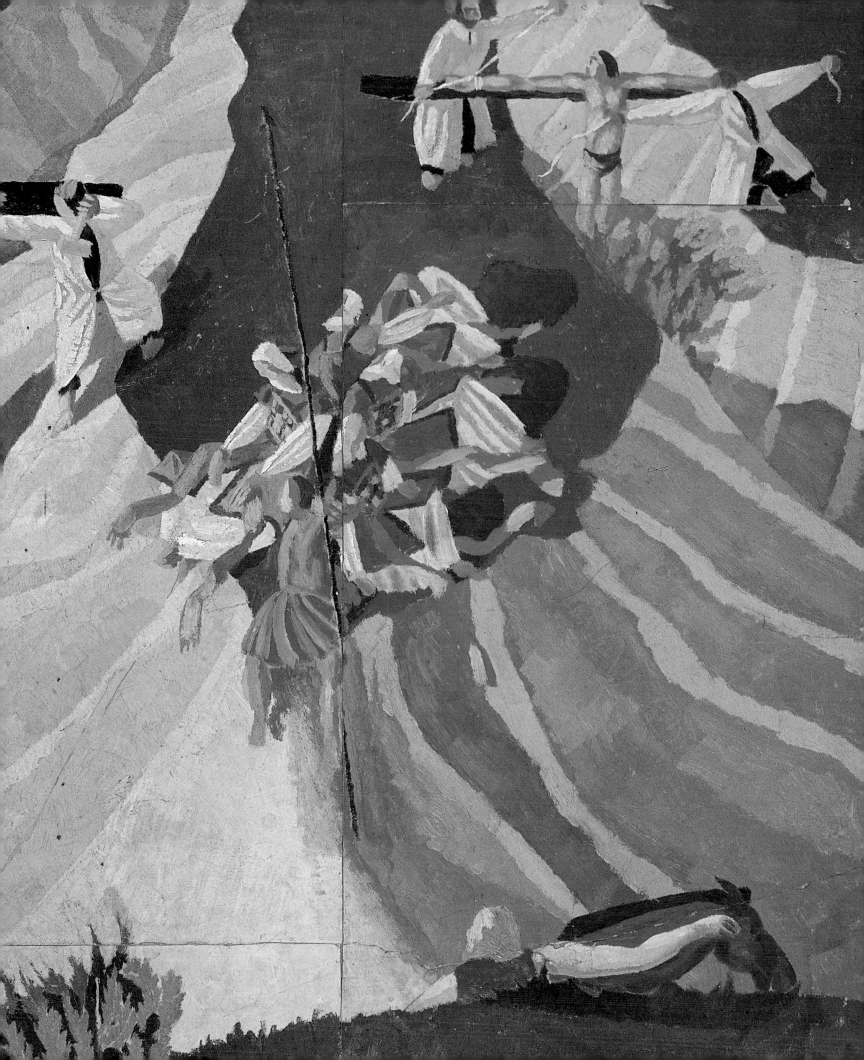

Spencer was determined to reinforce the parallel by mastering the art of true fresco: 'I shall do a bit of fresco painting on the quiet in Sydney's outhouse at the back of his studio,' he wrote to Hilda Carline in October, adding 'I shall tell the Behrends nothing of my fresco studies . . . as it would only bother and worry them.'[21]

The engagement of Stanley Spencer to Hilda Carline was broken and renewed a number of times before they were married in March 1925 in the parish church of Wangford, near Southwold. Meanwhile, Spencer was at work on a canvas which dwarfs *Travoys*. He began his painting of *The Resurrection, Cookham* [pl. 26] in February 1924, in Henry Lamb's studio, where Sir John Rothenstein recalled that 'the room was barely large enough to accommodate the immense canvas, measuring some eighteen feet long by nine feet high, which leaned against the longest wall. Up against the canvas stood a small table – which, with two kitchen chairs and a small tin bath, was the room's only furniture – and upon it a large teapot, half a dozen unwashed plates and some white marmalade jars, some containing paint brushes and others marmalade.'[22] To that description can be added Kate Foster's observation in her diary of Spencer himself 'teetering on a box while painting white roses in a corner, just a patch at a time, and holding forth from his elevation on Tonks and the Slade.'[23]

As we know, the subject was not a new one for the artist. He had begun a painting of the Resurrection while at the Slade[24] and completed another version, *The Resurrection of the Good and the Bad*, in 1915.[25] By 1923 he had also resolved to incorporate the theme into his war memorial; to quote again from his letters to Hilda Carline: 'The end wall is to be a tall circular topped picture of that idea I told you about – the resurrection of the soldiers in Salonica.'[26]

But before he could redeem his comrades-in-arms, he had to complete his testament to Cookham. In spite of Spencer's attempt, after the war, to regain the innocence of his youth, the thirty-four-year-old artist had to face up to the changes which had taken place. He could not forget the experiences of 1915–18, nor could he turn his back upon new friends, married life and the prospect of support, for several years, from a major commission. At this turning-point in his career he chose to paint a picture which looked backwards as well as forwards, or perhaps it is more accurate to describe it as ageless in its defiance of time, in its revelation of eternity in Cookham churchyard.

When the picture was exhibited in 1927, it was recognized at once as an important work, 'a very personal conception carried through with unfailing nerve and conviction,' according to Roger Fry reviewing it in the *Nation and Athenaeum* (12 March). With some justice *The Times* critic (28 February) wrote that 'it is as if a Pre-Raphaelite had shaken hands with a Cubist.' Spencer's acknowledgements are both personal and artistic, an amalgamation of Cookham and the Slade into which he assimilated some of his more recent experiences. The Carlines, for instance, join the elect of Cookham as cheerful participants in the Day of Judgement. Richard Carline, who recalled posing nude for a figure rising from his tomb,[27] is clearly discernible next to Spencer himself, to the right of centre. Both reappear in other parts of the picture, as does Hilda Carline. 'And so in the resurrection there are the same beloved human ways and habits,' Spencer explained, 'Hilda mooches along and slowly goes over the stile. . . . Further down you see Hilda smelling a flower'[28]

For Spencer the inclusion of his wife meant far more than the convenience of having her available as a model. Just as the Carlines welcomed him into their family, so he had to repay the compliment by affirming their relationship once and for all to the Kingdom of Heaven-on-Thames. The keynote is one of joyful leisure, a recollection of those prewar days of 'beautiful wholeness.' 'No one is in

26 *The Resurrection, Cookham* (1924–26). Oil on canvas, 274 × 549 cm (108 × 216 in). Tate Gallery, London

any hurry in this painting ... they resurrect to such a state of joy that they are content.'[29] In the absence of reckoning or retribution, Spencer's souls return slowly to their senses, to smell the flowers, to touch the earth and to reach out to one another as they adjust to eternal life.

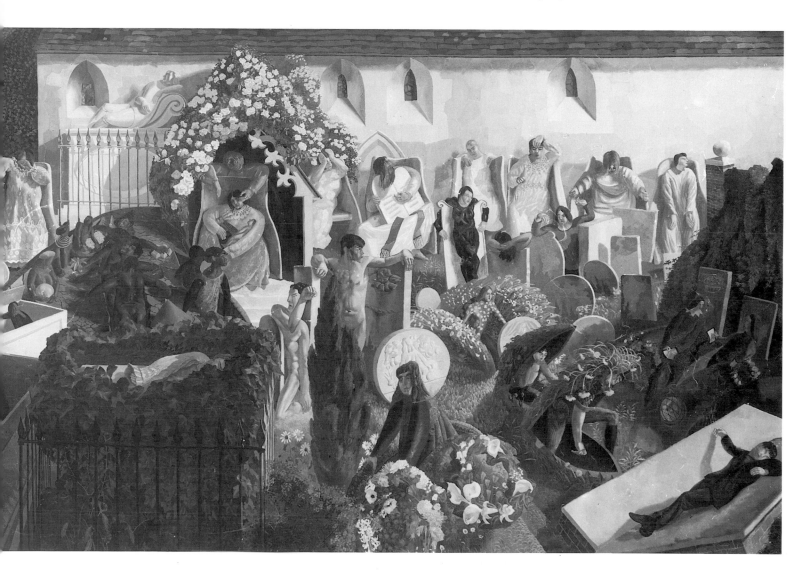

The Resurrection, Cookham was the centrepiece of Spencer's first one-man show which opened at the Goupil Gallery, London, in February 1927. It not only enjoyed a favourable reception; it was bought from the exhibition by the Duveen Paintings Fund and was presented to the Tate Gallery. Spencer also took the opportunity to display several studies which referred explicitly to his wartime experiences and to his commission from the Behrends. His early oil sketches of *Scrubbing Clothes* and *Making a Red Cross* were included, together with the designs for the north and south walls of the memorial chapel. By then construction was well under way. The building was dedicated as the Oratory of All Souls by the Bishop of Guildford on 25 March 1927, the feast of the Annunciation and the same day on which the Arena Chapel had been consecrated in Padua some six centuries earlier.

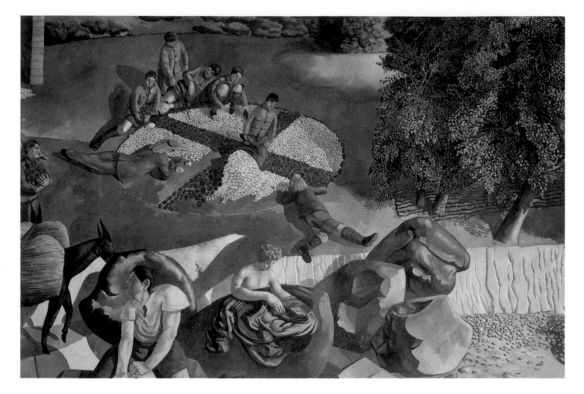

27 *Riverbed at Todorova*, detail (1931). Oil on canvas, Sandham Memorial Chapel, Burghclere (National Trust)

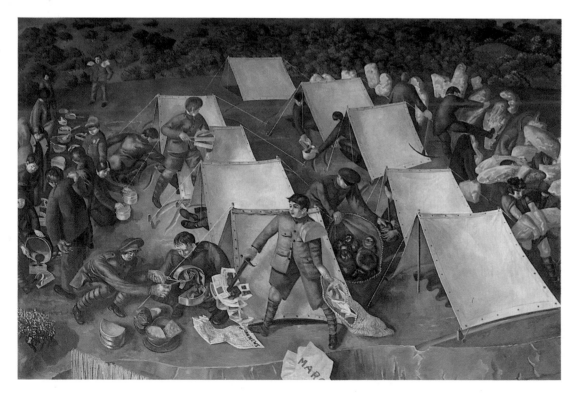

28 *The Camp at Karasuli*, detail (1930). Oil on canvas, Sandham Memorial Chapel, Burghclere (National Trust)

29 RIGHT: *The Resurrection of the Soldiers*, east wall (1928–29). Oil on canvas, Sandham Memorial Chapel, Burghclere (National Trust)

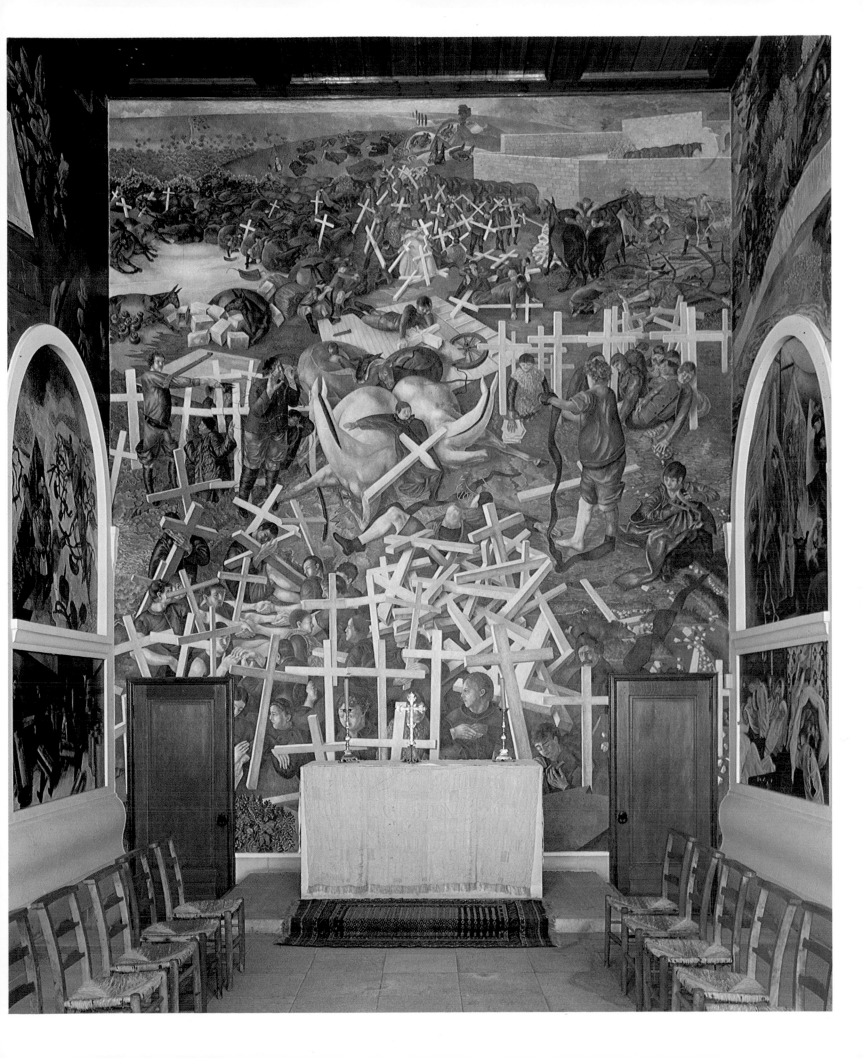

Burghclere

In May 1927, Stanley and Hilda Spencer moved, with their baby daughter Shirin, to Burghclere. For several months they lived in rented accommodation at Palmer's Hill Farm, because Chapel View, the house which the Behrends were building for them, was unfinished. But once the chapel itself was ready, Spencer was determined to begin working on it.

Before leaving Hampstead, he had abandoned the notion of painting in fresco. In fact he had completed two of the smaller canvases, or predellas as he called them, which were designed to occupy the lowest registers of the north and south walls, in bands of four on each side. *Scrubbing the Floor* and *Sorting and Moving Kit-Bags* correspond in detail to the first two scenes indicated in the study or sketch-plan of 1923 [pl. 30]. They introduce a succession of incidents recalled from Spencer's earliest military service, at Beaufort Hospital. Like his training there, they provide the basis for what follows in the scenes above.

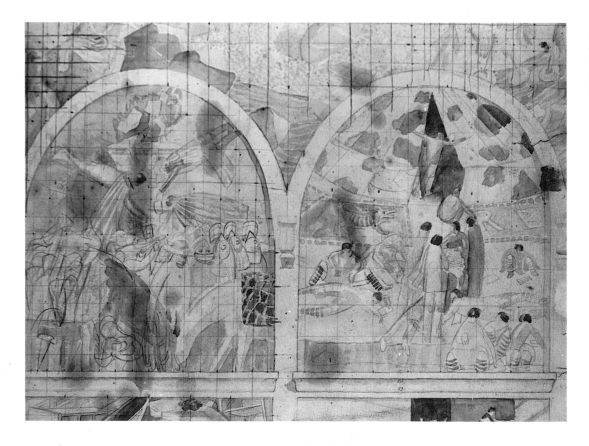

30 Study for the *Sandham Memorial Chapel, Burghclere* (1923). Pencil and wash on paper, 55.9 × 72.4 cm (22 × 28½ in). Stanley Spencer Gallery, Cookham

Spencer deliberately chose as subjects the most commonplace of his duties as an orderly. As he explained in a lecture he gave in 1923 to the students at the Ruskin School of Drawing in Oxford: 'The thing which interests me and has always done is the way that ordinary experiences or happenings in life are continually developing and bringing to light all sorts of artistic discoveries. . . . When I scrubbed floors, I would have all sorts of marvellous thoughts, so much that at last, when I was fully equipped for scrubbing – bucket, apron and "prayer mat" in hand – I used to feel much the same as if I was going to church.'[1] The rule of the commonplace is equally applied to his panoramic scenes of military encampment which span the upper sections of the walls. Unlike the predellas and the taller, arch-topped canvases which were painted as easel pictures prior to their installation, the uppermost sections of the north and south walls, together with the entire east wall, had to be painted *in situ*. Especially wide bolts of Belgian canvas were ordered. The walls were then lined with an underlay of asbestos cloth over which the canvas was glued before Spencer began to work from the scaffolding which Mr Head, the builder, erected in the chapel during the summer of 1928. The campsites he depicted were in Macedonia; details such as *Scrubbing Clothes* and *Making a Red Cross* are familiar from the oil sketches of 1919 and are repeated alongside other mundane tasks [pl. 27]. Private Spencer strides around *The Camp at Karasuli* [pl. 28], picking up litter with the point of his bayonet while his comrades perform similar domestic chores. Where Michelangelo placed prophets in the spandrels between the arches in the Sistine Chapel, Spencer has a brawny soldier in shirtsleeves, perched on a rock above the river, scrubbing a pair of undershorts. Whether it is irony or not, it is intentional: his version of the heroism of modern life.

It has often been pointed out that violence and suffering are entirely absent from these pictorial descriptions of the Great War, on the home front and abroad. In his original scheme Spencer planned to include a painting of a surgical operation. In the summer of 1916 he had written to his young friend Desmond Chute: 'I should love to do a fresco of an operation . . . and have the incision in the belly in the middle of the picture and all the forceps radiating from it.'[2] An ink sketch in the letter anticipated the more developed drawing which Spencer included in the overall design of 1923 [pl. 30] but later rejected as too painful a subject.

Instead, the references to physical pain are oblique. For instance, the first of the arch-topped canvases at the west end of the north wall depicts a truckload of wounded soldiers entering the hospital gates [pl. 31], but they are not the shrouded, front-line casualties he painted at the field-dressing station in Smol; they are the thankful survivors who have travelled all the way back to convalescence in England. Their arrival at Beaufort Hospital is treated almost festively, with the rhododendrons in full bloom beyond the railings of the gate, 'a vile cast-iron structure . . . as high and massive as the Gates of Hell,' as Spencer described his own first sight of it.[3] The steep perspective into which the painter somehow contrives to look down is a favourite device of his and one he often used, no doubt to compensate in painting for his own lack of height. It is a characteristic of all eight of the principal scenes, their verticality emphasized by virtually no horizons, in or out of doors.

Yet in other ways, the individual canvases vary in mood and tone. *Convoy of Wounded Men Filling Water-Bottles at a Stream* [pl. 36] and *Making a Fire-Belt* are animated to the point of frenzy, while in *Map-Reading* [pl. 37], placed between them on the south wall, 'the map nearly fills the picture,' as Spencer explained to Richard Carline, 'with men, down below, resting on either side of the road. I love this scene for the obvious reason of resting and contemplating.'[4] It is the only one of the

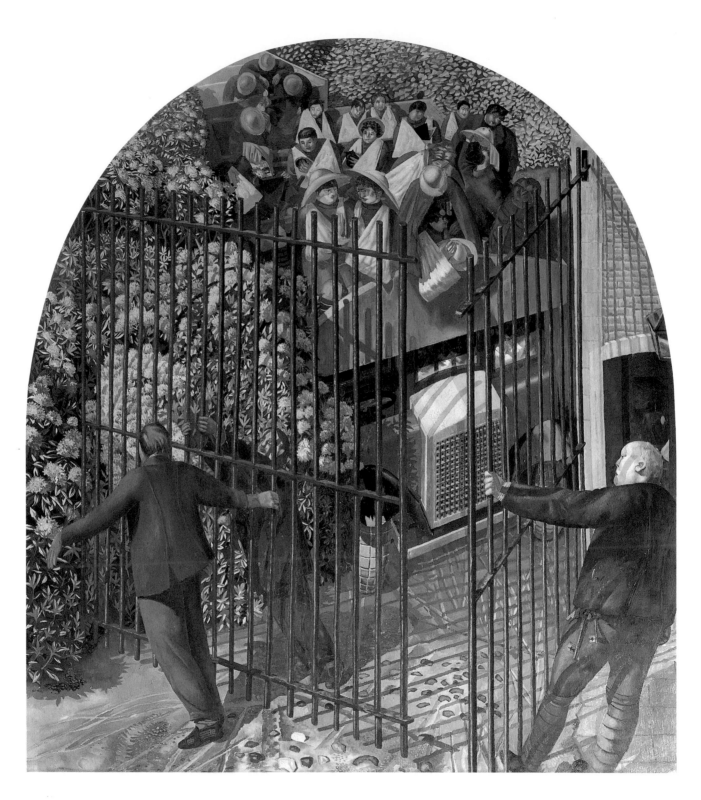

31 *Convoy of Wounded Soldiers Arriving at Beaufort Hospital Gates* (1927).
Oil on canvas, 213.4 × 185.4 cm (84 × 73 in).
Sandham Memorial Chapel, Burghclere (National Trust)

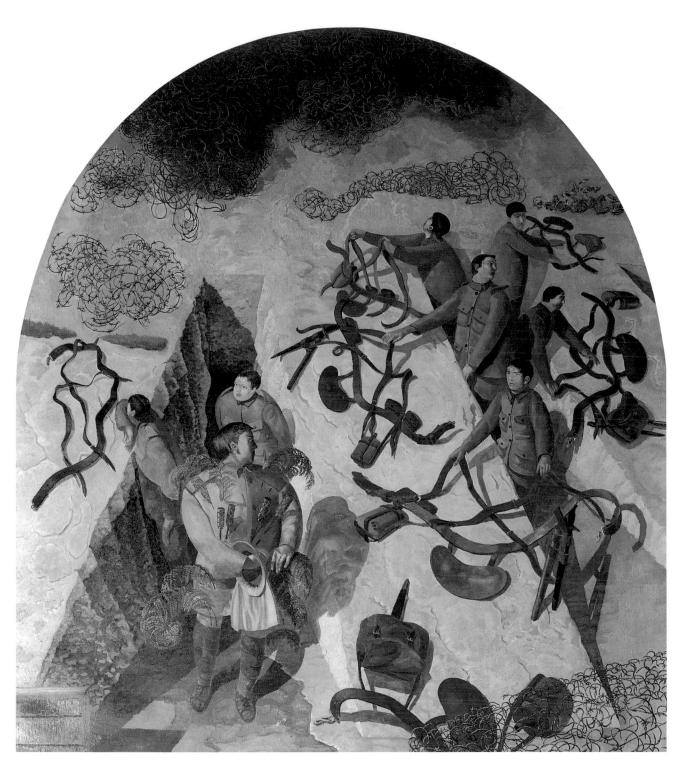

32 *Dug-out or Stand-to* (1928).
Oil on canvas, 213.4 × 185.4 cm (84 × 73 in).
Sandham Memorial Chapel, Burghclere (National Trust)

illustrations in which an officer takes charge, albeit surrounded by his men at ease. Some of them sleep, while others clamber among the lush vegetation in search of berries. Wildflowers and shrubs are painted with something more than a keen eye for botanical accuracy; momentarily at least, 'the winter is past . . . the flowers appear on the earth . . . the time of the singing of birds is come.' This is not the only case of pictorial metaphor, 'a mixture of real and spiritual fact, as the underlying intention is a great feeling of peace and happiness.'[5]

One of the most moving of the Burghclere paintings is *The Dugout* [pl. 32], the subject added when Spencer eliminated his representation of an operating theatre and moved *Kit Inspection* into the third bay of the north wall. Two trenches are shown in steep perspective at right angles to the foreground. They are cut clean into the crust of the earth to provide the only breaks in its barren surface, in a well lit desert where entangled thickets of barbed wire replace natural vegetation. It is an image of desolation, a setting which would not look out of place beside one of Paul Nash's surreal landscapes. But Spencer's vista is anchored in reality by its inhabitants. The men follow their sergeant as he emerges from the dugout into the uncanny light of day, busily camouflaging his hat and turning to issue orders amidst the litter of military equipment thrown on to the ground. The resemblance of the soldiers to the reincarnate souls who rise from their graves in Cookham churchyard is more than a coincidence. The figure of the sergeant derives from a drawing of a *Camouflaged Grenadier* which Spencer made *c.* 1928[6] and which, according to Gilbert Spencer, was a recollection of a particularly daring soldier whom Spencer remembered, killed in action in Macedonia. Spencer described *The Dugout* to his brother-in-law as 'a sort of cross between an "Armistice" picture and a "Resurrection",' a pictorial realization of the fantasy he had on active service, that one morning he and his comrades would wake to find the war was over. For him, as for the poet Edward Thomas, the metaphor of sleep had further implications:

> I have come to the borders of sleep,
> The unfathomable deep
> Forest where all must lose
> Their way, however straight,
> Or winding, soon or late;
> They cannot choose.[7]

In the thick of battle, it might well have seemed that eternal rest was more likely than peace among nations, and Spencer was aware of the poignant ambiguity with which he represented 'the circumstances in which the resurrection finds these men. This picture is really an introduction from the side-wall, ordinary army life pictures, to the end wall *Resurrection* picture. It is a mixture of an ordinary circumstance with a spiritual happening.'[8]

The east wall forms the climax to the cycle, both visually and spiritually [pl. 29]. As we know from his letter to Hilda Carline cited in Chapter 2, Spencer had decided as early as 1923 to devote 'the end wall . . . to . . . a tall circular topped picture of . . . the resurrection of the soldiers in Salonica.'[9] But he continued to struggle with the composition for several years. In 1927 he confided to Richard Carline that he was thinking of 'filling the whole end wall with barbed wire,'[10] an idea he abandoned in favour of the one studied in a drawing in the Fitzwilliam Museum, Cambridge [pl. 34], which shows the figure of Christ seated in impassive majesty, surrounded by soldiers who stack their crosses

33 David Bomberg (1890–1957), *'Sappers at Work': A Canadian Tunnelling Company*, first version (1918–19). Oil on canvas, 304 × 244 cm (121½ × 97¾ in). Tate Gallery, London

34 Study for *The Resurrection of the Soldiers* (c. 1927). Pencil, blue and grey wash on paper, 35.6 × 25.4 cm (14 × 10 in). Fitzwilliam Museum, Cambridge

around him. Carline cited and reproduced a lost cartoon from the same year,[11] in which the upper portion of the composition was resolved, but the problem of the foreground remained; beneath the two white mules in the centre, fallen soldiers were depicted at eye level, their huge, foreshortened limbs sprawling in an ungainly way towards the spectator.

Between then and the autumn of 1928, when Spencer began work from the scaffolding, he devised his final and brilliant solution. Near life-size figures occupy the pictorial space behind the altar wall. They are immediately recognizable as portraits of the soldiers with whom Spencer shared that life of hardship, fear and suffering which ended for so many of them in violent death. A decade after the event Spencer was able to recall each of them as individuals: the curly-haired Welshman above the altar to the left, the profile of a pensive young Englishman on the right, his elbows appearing to rest on the actual surface of the altar, as he emerges from the heap of crosses piled on and around it in a startlingly effective *trompe-l'œil* of resurrection. The actual church furnishings, the silver cross and candlesticks placed on the altar, are liturgically unnecessary. The painting itself is full of crosses which are heavy with both descriptive and symbolic meaning.

Spencer must have seen those military cemeteries which were planted all over northern Europe as a result of the war, with serried ranks of simple, white-painted wooden crosses, each one representing a fallen soldier. He chose to paint these not in neat, graveyard rows, but on the Day of Judgement, as they are uprooted by their owners and heaped as the redundant symbols of personal sacrifice on the actual altar in the foreground and around the painted figure of Christ above, in the distance of a new Macedonian dawn. For Spencer's painting not only commemorates his dead comrades, it offers them salvation. The absence of violence is not the result of cowardice or squeamishness; it represents a spiritual value. The fury of war, the frustrations of life in the ranks, the suffering even unto death are finally transformed into a state of grace. As Spencer put it, 'the Burghclere memorial ... redeemed my experience from what it was; namely something alien to me. By this means I recover my lost self.'[12]

Even as Spencer painted, his efforts on the Oratory of All Souls attracted widespread attention. In addition to his own circle of friends, which included the Carlines, the Lambs and the Bones, Duncan Grant and Vanessa Bell went to see him at work and were followed by other members of the Bloomsbury Group. According to Richard Carline, he welcomed the interruptions and was amused by the least discerning of his visitors, including the clergyman who shut his eyes when preaching and 'always looked at my pictures in the same way.'[13] Others were more perceptive. In 1922, just after the completion of the project, the critic R. H. Wilenski wrote that 'by the artist's side ... we smell the flesh of the herded soldiers, we feel the texture of their clothes and towels, the exact consistency of every object they handle.'[14]

For Spencer the detail was necessary; his earliest ideas for the chapel decoration reveal a deep-seated need to relive his experiences in order to overcome them. Among his contemporaries, reactions to similar circumstances varied. Artists like Nevinson and Wyndham Lewis went to war with the light of Futurism burning in their eyes. They found excitement in the hot and cold steel of the modern battlefield and identified men with the machinery of the world's first mechanized war. In Nevinson's painting of *Returning to the Trenches* [pl. 35] the column of marching soldiers is welded into a single unit of dynamic movement, an impersonal force in which arms and men operate on equal terms as components. Wyndham Lewis celebrated a similar attitude as the editor of *Blast*, the wartime

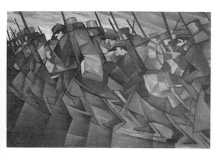

35 Christopher Richard Wynne Nevinson (1889–1946), *Returning to the Trenches* (1914–15). Oil on canvas, 51 × 76 cm (20½ × 30½ in). National Gallery of Canada, Ottawa

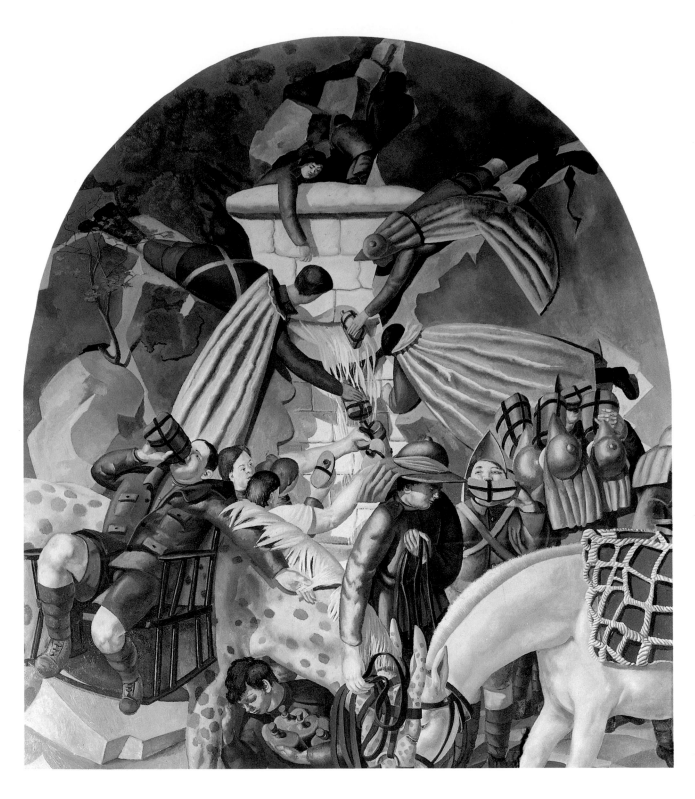

36 *Convoy of Wounded Men Filling Water-Bottles at a Stream* (1932).
Oil on canvas, 213.4 × 185.4 cm (84 × 73 in).
Sandham Memorial Chapel, Burghclere (National Trust)

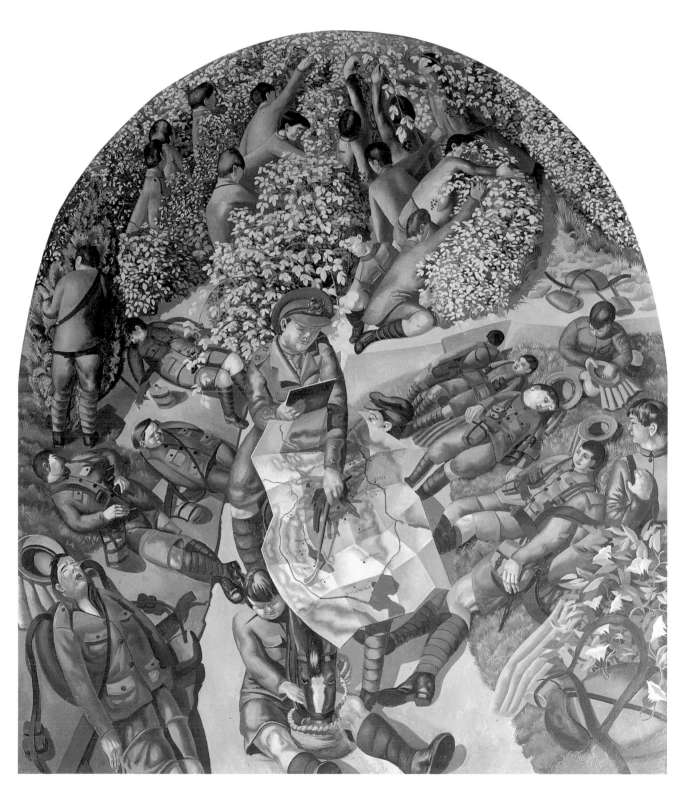

37 *Map Reading* (1932).
Oil on canvas, 213.4 × 185.4 cm (84 × 73 in).
Sandham Memorial Chapel, Burghclere (National Trust)

manifesto of the Vorticists to which his friend, the young French sculptor Henri Gaudier-Brzeska, sent a final contribution shortly before he was killed in action at Neuilly St Vast on 5 June 1915:

> THIS WAR IS A GREAT REMEDY
> IN THE INDIVIDUAL IT KILLS ARROGANCE, SELF-
> ESTEEM, PRIDE.
> IT TAKES AWAY FROM THE MASSES NUMBERS
> UPON NUMBERS OF UNIMPORTANT UNITS...[15]

By contrast, Spencer's pictorial memoirs are both personal and human. His paintings bustle with ordinary men in baggy clothes and crumpled uniforms. The dull earth colours of canvas and khaki predominate in the chapel, with its careful description of everyday life in the ranks as Spencer knew it. As we have seen, his autobiography of the war had to include the bathtubs at Beaufort as well as the dugouts and encampments in Macedonia; at the time and in both places, he clung, as a source of strength, to the minutiae of existence. Throughout, his perspective was that of Private Spencer, an individual among individuals, in spite of the regimentation of life in the army. His wartime letters are full of characters: from the formidable Sergeant-Major at Beaufort Hospital to 'the Black Prince' in the makeshift cook-house at Corsica Camp. 'I often think it would be interesting to get together all my best chums since the War began,' he wrote to his sister Florence in 1917. 'A good half the number would be drunk.'[16] Ten years later he painted his chums as he remembered them, distinct from one another and irrepressibly human even under orders.

Spencer's lifelong dislike of uniformity was the result of his relish for all the differences in appearance and temperament which distinguish people from one another. For him the general truth about humanity consisted of the sum total of its infinitely varied parts. Among the poets of the Great War, David Jones is the one whose vivid descriptions of life in the trenches come closest to the images in the Burghclere Chapel. He too spent more than a decade 'evolving his compositions' before he wrote *In Parenthesis*, using a vocabulary derived from scripture, Middle English and contemporary gutter-speak to find words enough for what he had undergone:

> The First Field Dressing is futile as frantic seaman's shift
> bunged to stoved bulwark, so soon the darking flood perco-
> lates and he dies in your arms.
> And get back to that digging can't yer –
> this aint a bloody Wake
> for these dead, who soon will have their dead
> for burial clods heaped over.
> Nor time for halsing
> nor to clip green wounds
> nor weeping Maries bringing anointments
> neither any word spoken
> nor no decent nor appropriate sowing of this seed
> nor remembrance of the harvesting
> of the renascent cycle
> and return
> nor shaving of the head nor ritual incising for these *viriles* under each tree.
> No one sings: Lully lully
> for the mate whose blood runs down.[17]

By means of specific quotation, expletives and all, Jones recaptured the individual accents of his companions, in a way which expressed his own affection and respect for them. Finally, he also redeemed them by relating their experiences, and his own, to Homeric epic, Celtic myth and Christian faith.

Spencer worked in the Sandham Memorial Chapel for the better part of four years. In contrast to the experiences he was re-creating there, life in the village of Burghclere appeared to be virtually unclouded. In paintings such as *Cottages at Burghclere* of 1929 [pl. 38], he expressed his summery delight in the countryside to the west of Cookham, on the borders of Berkshire and Hampshire.

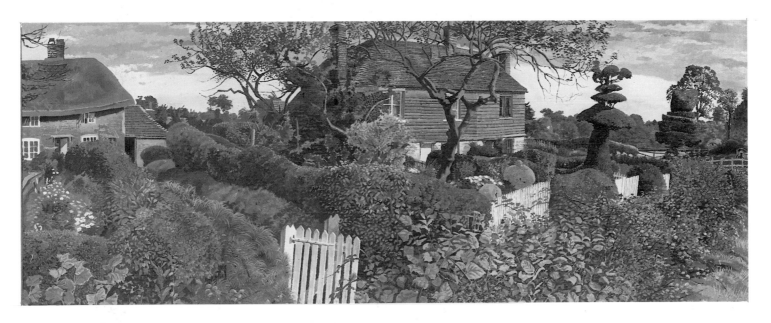

38 *Cottages at Burghclere*
(*c.* 1930–31). Oil on canvas,
62.2 × 160 cm (24½ × 63 in).
Fitzwilliam Museum, Cambridge

Later in his career Spencer made a point of dismissing his landscapes as 'pot-boilers.' Yet that fact belies the sense of place which is fundamental to his art. As we have seen, his early visions were inseparable from Cookham and its hinterland. In the thick of war in the Balkans, he discovered a 'longing for something "findable" in that country, which lasted for the two and a half years that I was there and for years after,'[18] at least until he could appropriate the landscape as the setting for the *Resurrection of the Soldiers*.

And at precisely the same moment, beyond the chapel walls, Spencer found both inspiration and consolation in the meadows, lush hedgerows and country gardens of rural England. He did so at a time when other painters and poets were turning (or returning) to the land. His brother Gilbert Spencer, John Nash [pl. 42] and Paul Nash were among those who alluded in different ways to

> . . . a season of bliss unchangeable
> Awakened from farm and church where it had lain
> Safe under tile and thatch for ages since
> This England, Old already, was called Merry.[19]

Georgian poetry, like the painting of the period, treats the familiar themes of retreat into the landscape and communion with nature, a regenerative process to which the son of Cookham certainly subscribed. As in so much of his painting, the detail in Spencer's landscapes is possessive and protective of

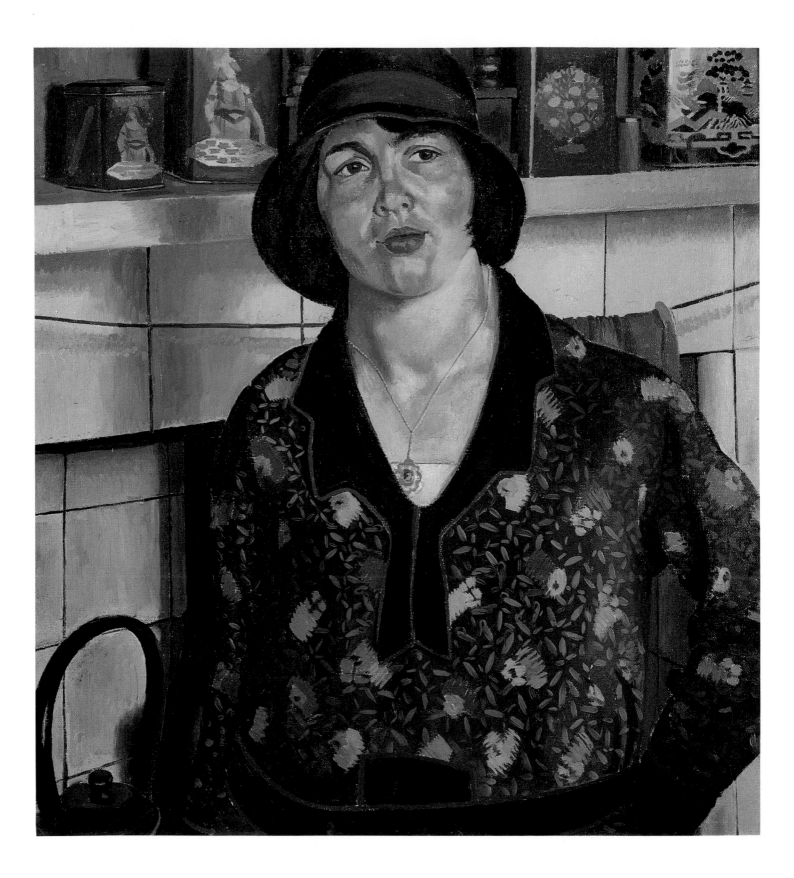

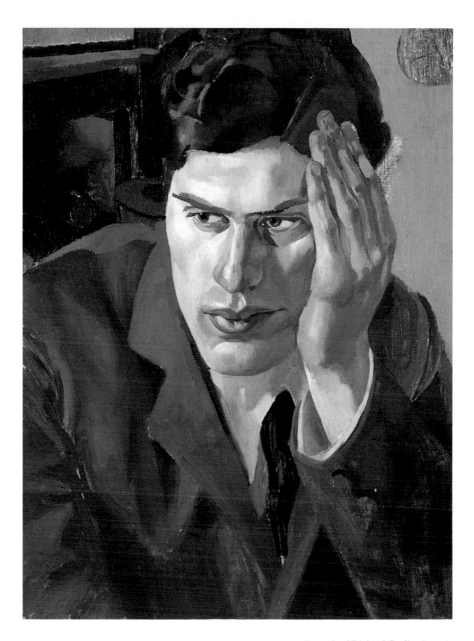

40 *Portrait of Richard Carline* (1923).
Oil on canvas, 54.4 × 39.5 cm (21½ × 15½ in).
Rugby Borough Council (on
loan to the University
of Warwick)

39 *Country Girl: Elsie* (1929).
Oil on canvas, 83.8 × 76.2 cm (33 × 30 in).
Private collection

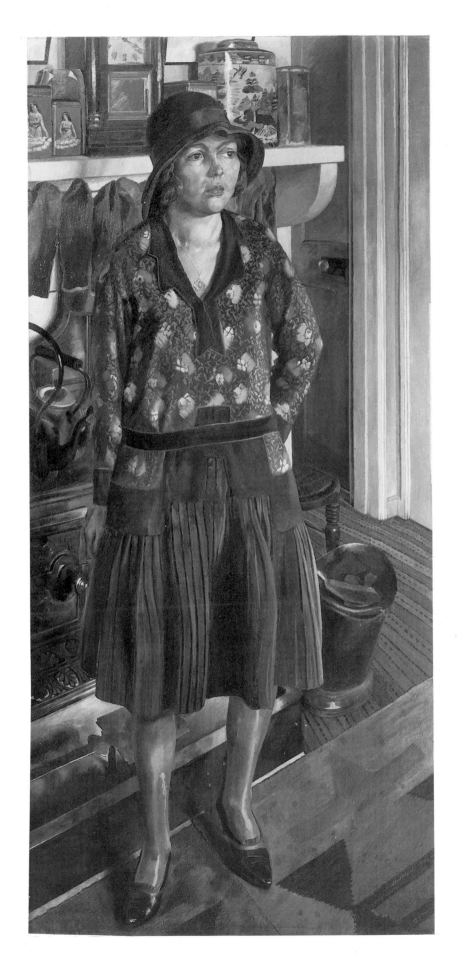

41 Hilda Spencer (1889–1950), *Portrait of Elsie* (1931). Oil on canvas, 172.7 × 81.3 cm (68 × 32 in). Private collection

42 John Nash (1893–1977), *The Moat, Grange Farm, Kimble* (1922). Oil on canvas, 76 × 51 cm (30½ × 20½ in). Tate Gallery, London

its subject. His reaction to the encroachments of the early twentieth century upon the English countryside is similar to that of John Betjeman, whose poem 'The Old Liberals' laments modernity without succumbing to all of the illusions associated with nostalgic ruralism:

> Such painstaking piping high on a Berkshire hill
> Is sad as an English autumn heavy and still,
> Sad as a country-silence, tractor-drowned;
> For deep in the hearts of the man and the woman playing
> The rose of a world that was not has withered away.[20]

As one of their concessions to the present, the Spencers were the proud owners of a motor car, an even greater luxury in 1928 than their other, of having a live-in servant. Elsie Munday joined them soon after their move to Burghclere and rapidly became an integral part of the family, which expanded again in 1930, with the birth of the Spencers' second daughter, Unity.

Like her brother Richard, Hilda Carline aspired to follow in her father's (and grandfather's) footsteps as a painter. When Spencer met her, she was a student at the Slade School, and she continued to paint after their marriage. In October 1929, both Spencers made portraits of Elsie, standing with her back to the kitchen range at Chapel View [pls. 39 and 41]. Stanley Spencer's is the more intense of the two, with its concentration upon the head and shoulders, to the exclusion of all but a fraction of the mantlepiece. In Hilda Spencer's full-length portrait Elsie stands somewhat less confidently in identical clothes and pose against an expanded background which details the stove, the kettle and the clothes-line at which Stanley Spencer merely hints. Six years later he chose the same setting for his painting of *Workmen in the House* [pl. 53], in which Elsie is shown struggling with her gaiters as she prepares to take one of her charges, Shirin, out for a walk.

This and other domestic scenes feature prominently in Spencer's painting from 1935 onwards. He painted *Hilda and I at Burghclere* [pl. 91] in 1955, a fond recollection of daily life as it had been twenty-five years earlier. No less than his reminiscences of the war, these paintings reflect his belief that 'there was a great deal of order in domestic things.'[21] Like the chapel itself, Chapel View became, in Spencer's mind, sacred to the memory of personal experience. He painted both in retrospect, as a 'means [to] recover my lost self.'[22]

Chapels in the Air

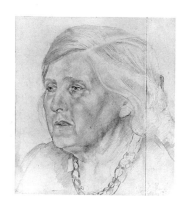

44 *Portrait of Mrs Carline* (1931). Pencil, two sheets joined, 34 × 31.7 cm (13¾ × 12½ in). From the collection of the late Richard Carline

As work on the chapel neared completion, Spencer's thoughts returned to Cookham. In the summer of 1929 he and his extended family, including Hilda's brother, Richard, and their mother, Mrs Carline [pl. 44], spent several weeks there. Two years later he and his wife began to look at houses in the village, and in October 1931 they decided to buy Lindworth, a large, semi-detached house some fifty yards away from Spencer's childhood home. They left Burghclere in the following spring, and Spencer finished the remaining canvases for the chapel in the studio he arranged to have built in the garden of his new house.

The native returned in triumph. By the age of forty, Spencer had earned widespread recognition as a painter. Among his supporters he could count such influential figures as R. H. Wilenski and Elizabeth and John Rothenstein. His patrons included some of the leading collectors of contemporary art in Britain, Sir Edward Marsh and the Behrends among them, and he was represented by a major easel painting in the permanent collection of the Tate Gallery. Furthermore, in a period characterized by attempts to take art beyond the gallery,[1] Spencer's decorations in the Sandham Memorial Chapel established him as a leading muralist. In 1932 he was elected Associate of the Royal Academy and was invited to show ten works (five paintings and five drawings) in the British Pavilion at the Venice Biennale. A year later, in Pittsburgh, one of his paintings was singled out for honourable mention by the judges of the Carnegie Institute's International Exhibition.[2] At home and abroad Spencer's reputation seemed assured.

Behind the façade of success tensions of a personal and an artistic kind were barely discernible. Yet Spencer's marriage was evidently showing signs of strain. For all the benefits of life in Burghclere, among his friends he voiced disappointment and irritation,[3] feelings which can only have encouraged restlessness and reinforced his leaning homeward, towards Cookham. And after the summer of 1929 his birthplace held a further attraction in the person of Patricia Preece [pl. 47], another painter who had trained at the Slade and in Paris before she and her companion, Dorothy Hepworth, decided to live in a house on the edge of Cookham Moor. She introduced herself to the Spencers one afternoon in the village tea shop, an event which Spencer later transferred in his portentous painting of *The Meeting* [pl. 45] to that passageway behind Fernlea in which he had envisaged (and witnessed) *The Betrayal* of 1923. The final irony of that coincidence was not to be apparent for several years.

In 1932, when Spencer finished the last of the Burghclere paintings, he completed a scheme which he had designed ten years earlier. While he had developed in the meantime as a landscape painter, he had deliberately invested the greater part of his creative talents for most of a decade in a singular enterprise which threatened to isolate him from the fast-moving mainstream of contemporary art. It was a danger against which his new friends offered some protection; Patricia Preece knew

43 *Hilda with Hair Down* (1931). Pencil, five sheets joined, 61 × 45 cm (24⅛ × 17¾ in). From the collection of the late Richard Carline

Paris as well as London, André L'Hôte as well as Roger Fry, while Dudley Tooth, who became Spencer's sole agent from 1932 onwards, was rapidly establishing himself as a dealer of international importance.

For his part Spencer had no intention of standing still. In spite of their narrative content and anecdotal detail, the Burghclere paintings reveal a growing tendency towards simplification in the treatment of the human figure. Those in the later canvases, *Tea in the Hospital Ward* and *Washing Lockers*, for instance, are defined by means of sweeping curves which establish boundaries for their rounded forms without interruptions from anatomy or dress. Facial features are accommodated wherever possible within the overall, oval profile of the heads, and shoulders are rounded in the interests of further anatomical simplicity. In appearance Spencer's figures belong to an international figure style of the 1930s which derives in part from the reaffirmation of the human form by a great many European artists after the Great War.

In Paris in the early 1920s, Picasso had launched into what became an extremely influential series of monumental bathers and other simply draped, neo-classical figures of immense proportions and presence. Their impact was felt by, among others in Britain, the sculptors Henry Moore and Barbara Hepworth. On the one hand, Moore's *Mother and Child* of 1924–5[4] reveals a knowledge of contemporary European art and its persistent Neo-Primitivism, while on the other, it proclaims the kind of monumental simplicity which Spencer had admired from his earliest days of reading Ruskin and studying composition at the Slade. Like Spencer, Moore was capable of combining the two traditions (with a greater debt to Fry than to Ruskin). A similar direction is apparent in the work of another former Slade student, William Roberts (1895–1980). A postwar fugitive from Vorticism in the late 1920s, Roberts began to impose the kind of strict geometry upon his figures that gives them a family resemblance to those of Fernand Léger. Beside all of these, the study Spencer made in 1933, *Making Columns for the Tower of Babel* [pl. 46] takes a natural place. It was also natural for him that it formed part of a more ambitious decorative scheme, albeit one which failed to materialize.[5]

In the introduction to the catalogue of his retrospective exhibition held at the Tate Gallery in 1955, Spencer wrote that 'all the figure pictures done after 1932 were part of some scheme the whole of which scheme when completed would have given the part the meaning I know it had.' In other words, he returned to Cookham in 1932 with a new agenda. 'The next chapel,' he explained '(built also in the air as was the first Burghclere Chapel, that is to say not commissioned) was to be planned somewhat thus: The Village Street of Cookham was to be the Nave and the river which runs behind the street was a side aisle.' Incredible as it may seem, Spencer's success with the Behrends encouraged him to think that lightning might strike twice. Whether it did or not, he had a clear idea of the task ahead. In a sense, the *Resurrection* of 1927 completed the Cookham Bible. It was followed by the secularized Passion played out on the walls of the Sandham Memorial Chapel in which Spencer sought to establish a new path to salvation through drudgery, 'and so it came about, at last, that tea-rooms, bathrooms, beds, etc. all became sort of symbols of my spiritual thoughts until at last I felt I could reveal the whole progress of my soul by stating clearly these impressions of my surroundings.'[6] Once again, the process was redemptive, the journey's end paradise, for which Cookham was the other name in Spencer's vocabulary. Marital problems can only have deepened his conviction that he must return and build a temple to his faith in Heaven-on-Thames.

Spencer described *The Meeting* as 'an attempt to do something which had the atmosphere I used

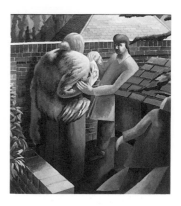

45 *The Meeting* (1933). Oil on canvas, 63.5 × 61 cm (27 × 24 in). Private collection

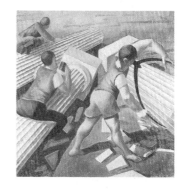

46 *Making Columns for the Tower of Babel* (1933). Oil on canvas, 53.9 × 48.9 cm (21¼ × 19¾ in). Private collection

47 *Portrait of Patricia Preece* (1933). Oil on canvas, 83.8 × 73.7 cm (33 × 29 in). Southampton City Art Gallery

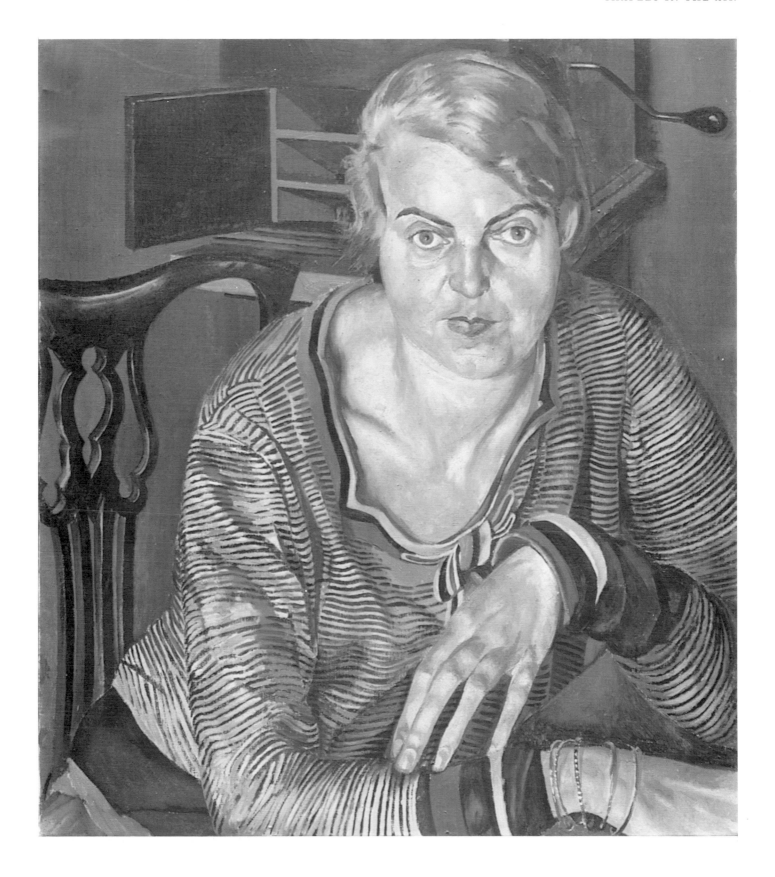

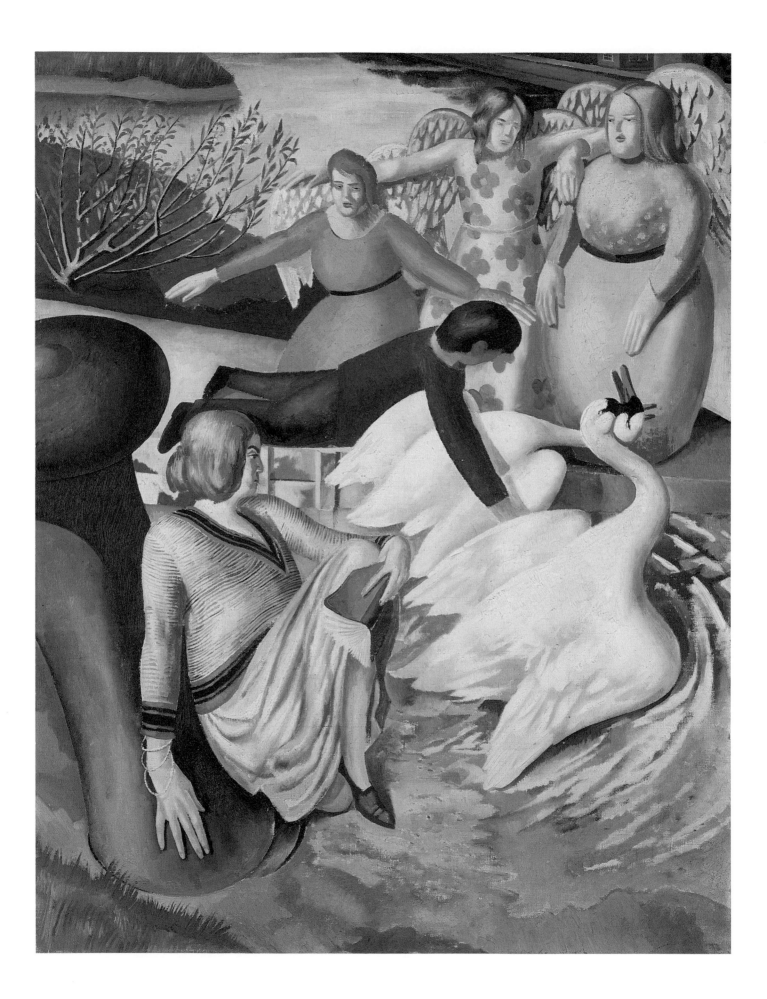

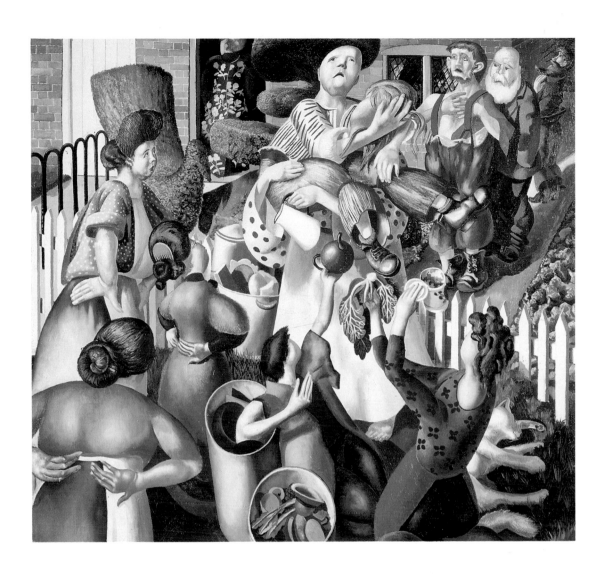

49 *The Dustman or The Lovers* (1934).
Oil on canvas, 114.9 × 122.5 cm (45¼ × 48¼ in).
Laing Art Gallery, Newcastle upon Tyne

48 *Separating Fighting Swans* (1933).
Oil on canvas, 91.4 × 72.4 cm (36 × 28½ in).
Leeds City Art Galleries

to feel before the war, but,' he added, 'it does not go far enough. It is more a note for further tendencies I wish to develop.'[7] In the painting he and Patricia Preece stand solemnly motionless, a new Adam and a new Eve at the gates of the old paradise between Fernlea and The Nest. Antony Gormley was the first to point out that Patricia's wrap is suggestive of the form of a swan,[8] thus providing a link with another painting of the same year, *Separating Fighting Swans* [pl. 48], in which the painter tried 'to combine an incident in my life with a person in my life, and a place in Cookham and a religious atmosphere.'[9] The 'person' once again is Patricia Preece, who watches, Leda-like,

50 *Sarah Tubb and the Heavenly Visitors* (1933). Oil on canvas, 94 × 104.2 cm (37 × 41 in). Private collection

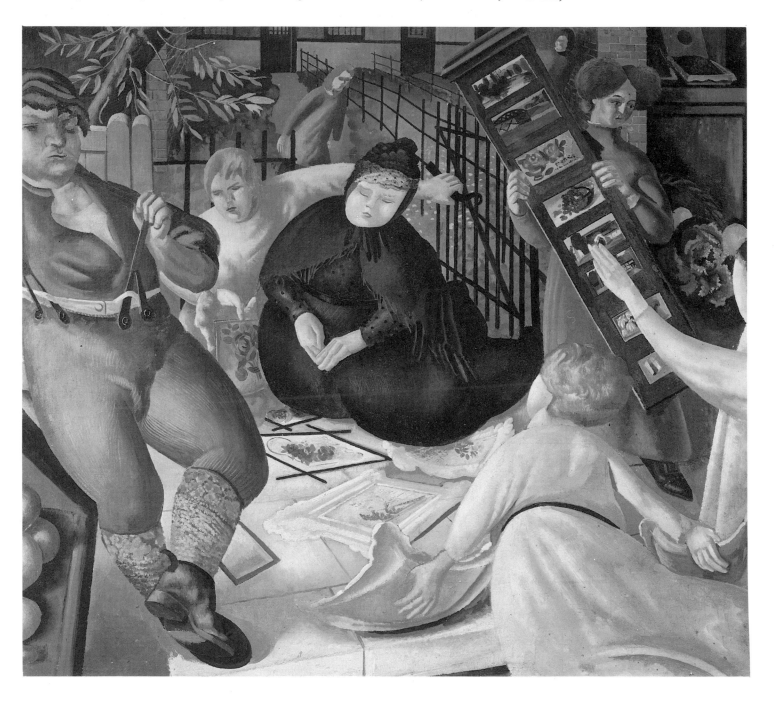

from the foreground as Spencer grapples almost lovingly with the birds. He in turn is observed by three angels, one of whom stretches out her arms in a gesture of protective benediction. In this painting the suppressed emotion of *The Meeting* is replaced by more explicit references to both sacred and profane love.

Not all of Spencer's paintings for the chapel in the air were so strictly autobiographical. Some, like *Sarah Tubb and the Heavenly Visitors* [pl. 50], were designed to illustrate the spiritual history of Cookham in terms of its oral traditions. Sally Tubb's place in local hagiography was assured by her reaction to the sight of Halley's Comet, which she took to be a portent of the end of the world. She promptly fell to her knees in the High Street and began to pray. In the painting Spencer surrounds her with 'Heavenly visitors,' the permanent residents of the holy suburb who comfort her and, as Keith Bell argues, welcome her to her place in eternity with gifts of 'all those things which she loved and which were so expressive of what she meant to me. . . . One presents her with a postcard of Cookham Church and another with a framed text.'[10]

Sarah (or Sally) Tubb is shown in the painting complacently kneeling, eyes closed and hands folded in prayer, a cosily bulging bundle of Victorian drapery. The heavenly figures around her recall the austere simplicity of Spencer's figure style *c.* 1920 (of the dematerialized spectators in *Christ Carrying the Cross*, for instance). By contrast, she and the looming figure of the man in working clothes shown as a nonchalant passer-by are more physically present, and like so many of the figures in the Sandham Memorial Chapel, their individuality is stressed, without any loss of affection on the part of the artist, to the point of caricature.

On the contrary, Spencer's predilection for physical differences in the human race became even more pronounced as he continued his divinely human comedy. In 1934 he added *The Dustman or The Lovers* [pl. 49] to what he continued to think of as his Church-house scheme, in spite of the dispersal by sale of the individual canvases as he painted them. Once again, the theme is resurrection, and the setting is Cookham. The incongruities are deliberate in a painting which sets out to convert refuse into the ritual of offertory. Spencer described his aim as 'the glorifying and magnifying of a dustman. The joy of his bliss is spiritual in his union with his wife who carries him in her arms and experiences the bliss of union which his corduroy trousers quicken.'[11] It is interesting that in writing about the picture Spencer made clear his self-identification with the diminutive male, carried like a babe in arms by the towering figure of his *Erdmutter*. The painting coincides in date with a drawing of a *Mother and Child*, in which Spencer caricatured himself and his wife as primitive sculptures.[12] He also included his father in *The Dustman or The Lovers*; the features of William Spencer are discernible in the bald, white-bearded workman awaiting his turn in the upper right corner of the canvas. The lovers themselves are surrounded by a congregation of 'other reuniting wives of old labourers' who empty dustbins (or garbage pails), strangely fruitful symbols of the dust-man's calling, in their search for solemn offerings. 'Nothing I love is rubbish,' Spencer insisted. 'And so I resurrect the teapot, and the empty jam tin, and the cabbage stalks, and as there is a mystery in the Trinity, so there is in these three and many others of no apparent significance.'[13] The sacred and the profane are mixed in equal proportions in a picture to which Spencer attached particular significance. He painted it at a time when his open courtship of Patricia Preece placed an intolerable strain upon his marriage. The relationship of the two principal figures, the male dwarfed by the female, anticipates the autobiographical *Beatitudes* of 1937–8, as well as Spencer's self-deprecating

OVERLEAF:

51 *The Beatitudes of Love: Passion or Desire* (1937). Oil on canvas, 76.2 × 50.8 cm (30 × 20 in). Private collection

52 *Domestic Scenes: The Nursery or Christmas Stockings* (1936). Oil on canvas, 76.5 × 91.8 cm (30⅛ × 36⅛ in). Museum of Modern Art, New York

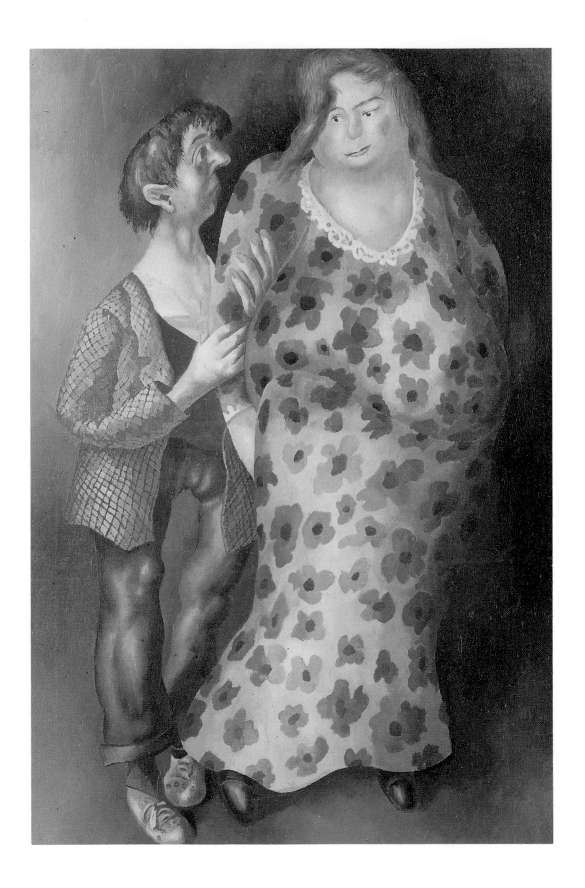

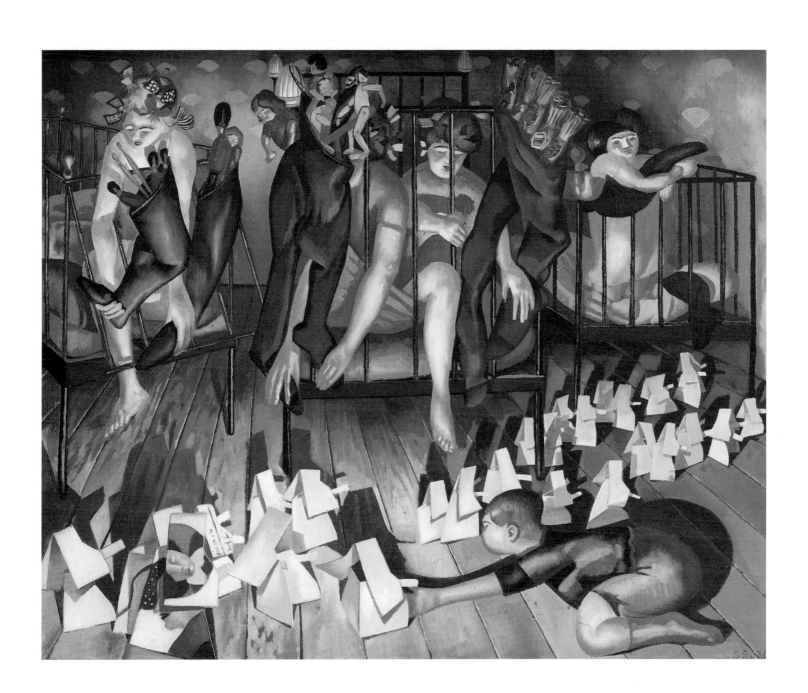

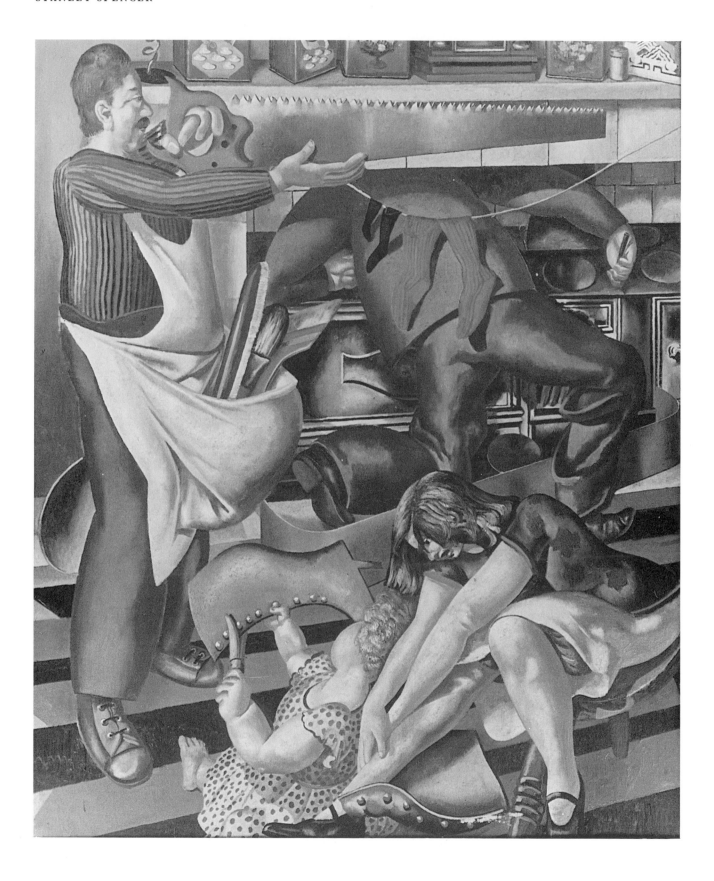

53 *Workmen in the House* (1935). Oil on canvas, 113 × 92.7 cm (44½ × 36½ in). Private collection

image of *Me and Hilda, Downshire Hill*, which he drew *c*. 1944 and which was unfinished as a painting at the time of his death fifteen years later.

Hilda Spencer's mournful rejection of her husband's bigamous designs adds a further dimension to *The Dustman or The Lovers* and its underlying text: 'I am always taking the stone that was rejected and making it the cornerstone in some painting of mine.'[14] As she discovered to her cost, he did not give up easily. In 1935, when separation took place and divorce became increasingly likely, Spencer launched into a series of autobiographical *Domestic Scenes* which rehearsed in paint moments of unclouded happiness from the past. *The Nursery or Christmas Stockings* [pl. 52] recalls one of his earliest memories, of Christmas Eve in the nursery at Fernlea. 'The children, who have their hair done up in bits of rag called curlers,' he explained in a letter to the Director of the Museum of Modern Art in New York, 'have come to the bottom ends of their respective beds to see what is in their Christmas stockings. On the floor a child is playing with paper nuns, making long processions out of them.'[15] In *Going to Bed* (private collection) Spencer revived a far more recent memory, from the infancy of his own children, and 'the special joy and significance at Burghclere the moment just before Hilda joined me in bed.'[16] While Hilda sits on a stool and removes her stockings, their two baby daughters clamber in naked abandon among the bedclothes. *Buttoning the Collar* depicts Hilda assisting her husband as he struggles with the formalities of dress, while yet another *Domestic Scene* represents the couple *At the Chest of Drawers* [pl. 54] with Hilda's larger form toppling precariously over the squatting figure of her diminutive spouse. Here too, in retrospect at least, Spencer appears to relish physical subservience to the mother of his children.

54 *Domestic Scenes: At the Chest of Drawers* (1936). Oil on canvas, 50.8 × 66 cm (20 × 26 in). Private collection

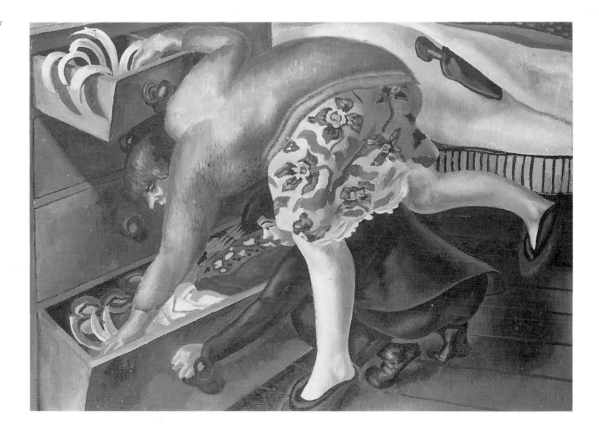

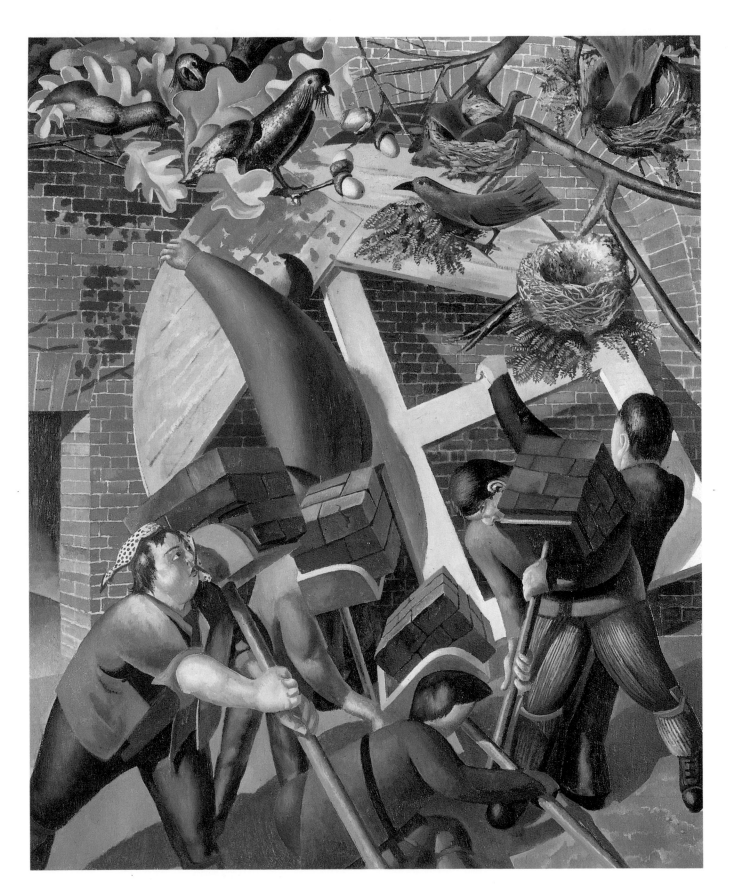

55 *The Builders* (1935).
Oil on canvas, 111.8 × 91.8 cm (44 × 36⅛ in).
Yale University Art Gallery, New Haven, Connecticut

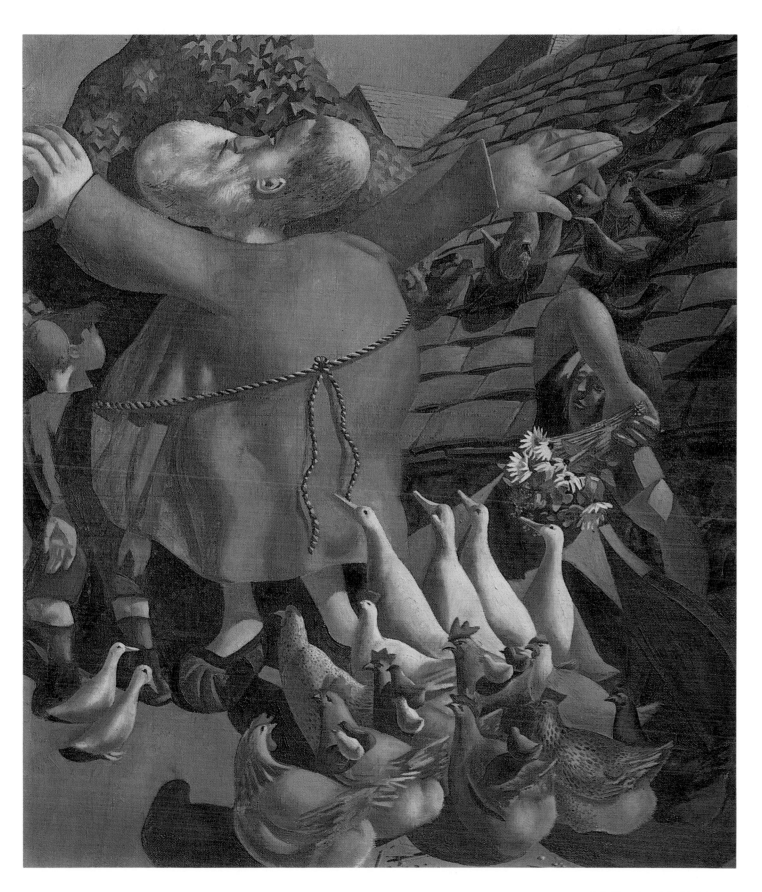

56 *St Francis and the Birds* (1935).
Oil on canvas, 71 × 61 cm (28 × 24 in).
Tate Gallery, London

As an Associate of the Royal Academy, Spencer was entitled to submit up to six works each year for consideration by the hanging committee for the Summer Exhibition. In May 1935 he sent in five canvases. Only one was uncontroversial: a landscape called *The Scarecrow, Cookham. Workmen in the House* [pl. 53] and its pendant *The Builders* [pl. 55] were also accepted for exhibition, although they had been rejected by Mr Boot, the builder who commissioned them with the single stipulation that they should focus upon his own trade. On the walls of the Academy they fared little better. The reviewer in the *Daily Mail* wrote: 'Nobody challenges Spencer's ability as a craftsman, the skill of his hand. What many people object to are some of his subjects when these are imaginative conceptions.' He went on to describe *Workmen in the House* as 'a tragi-comedy. A queer looking carpenter gazes down the length of an enormous saw. Another man is half-way up the kitchen chimney, in the foreground a distracted housewife and her child sprawl on the floor.'[17] This recollection of a mundane incident at Chapel View bears a superficial resemblance to the work of Mark Gertler or William Roberts, but like the Burghclere paintings, it depends heavily upon that autobiographical element which was, by definition, uniquely Spencer's own. There is a conscious humour in the juxtaposition of different kinds of workers; the men smug with manly pride as they invade the hearth with their tools erect (the pun is a visual one), while the nurse struggles with her responsibilities for the baby beneath the extra burden of obtrusive masculine intervention.

The painting of *The Builders* is at first sight less personal. It obviously relates not only to the commission of 1935, but also to the abortive *Tower of Babel* project, on which Spencer had worked two years earlier. Beyond that it is hard to avoid the conclusion that the image of building had a deeper resonance for the artist. In 1935 it expressed his continued preoccupation with chapels in the air, with bricks and mortar as the materials which were needed to translate his dreams into reality. And like *Workmen in the House* those dreams were identified with Burghclere, with Chapel View as much as with the Memorial Chapel. *The Builders* are quite literally building nests; the upper section of the canvas is filled with birds, eggs, acorns and oak leaves. The instinct was Spencer's own, the more keenly felt as the reality became a thing of the past. In the years ahead, the Church House was to assume importance as an ideal in direct proportion to its unattainability; as Spencer put it in 1938, 'my desire to paint is caused by my being unable – or being incapable – of fulfilling my desires in life itself.'[18]

The public crisis of 1935 was precipitated by the remaining two oils submitted by Spencer to the Academy. The hanging committee rejected *The Dustman or The Lovers* and *St Francis and the Birds* [pl. 56]. As usual, Spencer offered a disarmingly simple explanation for the painting which gave the greatest offence: the figure of St Francis was based upon that of William Spencer who, in eccentric old age, pottered around the village in his dressing gown.[19] In the picture this was combined with a totally different reminiscence: in a letter she wrote to her future husband in 1924, Hilda Carline mentioned the fact that she had been reading in a haystack. Her description prompted the drawing which appeared as an illustration for the month of August in the *Almanack* which Spencer designed for Chatto and Windus in 1927. It, in turn, determined the composition of *St Francis and the Birds*, in which the figure of William Spencer feeding poultry was 'fitted into the bulk and main lines of what was originally a haystack with a figure reading a book. The back of St Francis takes the line down the front of the figure in the haystack, and the cord round his waist takes the lines of the shoulders and arm of the figure.'[20] Neither the Academicians nor the public were mollified

57 *Love among the Nations* (1935). Oil on canvas, 95.5 × 280 cm (37⅝ × 110¼ in). Fitzwilliam Museum, Cambridge

by what was perceived as an assault upon the author of *The Mirror of Perfection*. 'Mr Spencer's St Francis is a caricature which passes the bounds of good taste,' in the words of the *Continental Daily Mail*'s reviewer of 27 April. Spencer's reaction to the judgement of his peers was to resign with noisy indignation. 'I never wanted to become an associate,' he told a *Standard* reporter. 'I do not approve of the Academy, but I thought the best way to change it was to join it.'[21] Opinions were divided among the Academicians themselves: Sickert supported Spencer while Munnings was vehemently opposed. Outside the gates of Burlington House there were those like Nevinson, who encouraged Spencer's revolt with their assertions that 'Stanley Spencer is far too good an artist to belong to the Academy.'[22] The value of notoriety was not lost upon a painter little given to compromise.

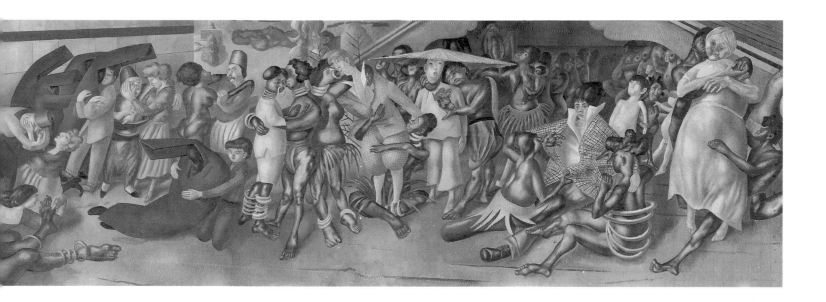

In 1935 Spencer painted a canvas in which the sexual implications of *The Dustman or The Lovers* became explicit. At first he called it *Humanity* and explained its genesis in terms of his wartime experiences: 'During the war, when I contemplated the horror of my life and the lives of those with me, I felt that the only way to end the ghastly experience would be if everyone suddenly decided to indulge in every degree and form of sexual love, carnal love, bestiality, anything you like to call it. These are the joyful inheritances of mankind.'[23] *Love among the Nations* [pl. 57] survives as a single canvas, although it was to have been the centrepiece of an important sequence of paintings decorating the nave of the Church–house. The later title is precisely descriptive of a picture in which races and creeds mingle in erotic pleasure. By the frank indulgence of their sexuality, they reconcile not only their own differences but also the very opposition which *The Dustman or The Lovers* had addressed between the sacred and the profane.

Spencer's campaign for sexual freedom was not unique in a generation which rejected the strait-jacket of Victorian morality. As we have seen, his early faith was deep and all-encompassing. Later, the individualist in him blamed St Paul as 'the originator of all that "get your hair cut" business that caused me so much trouble, he sounds like a Nazi to me.'[24] In his search for a broader and

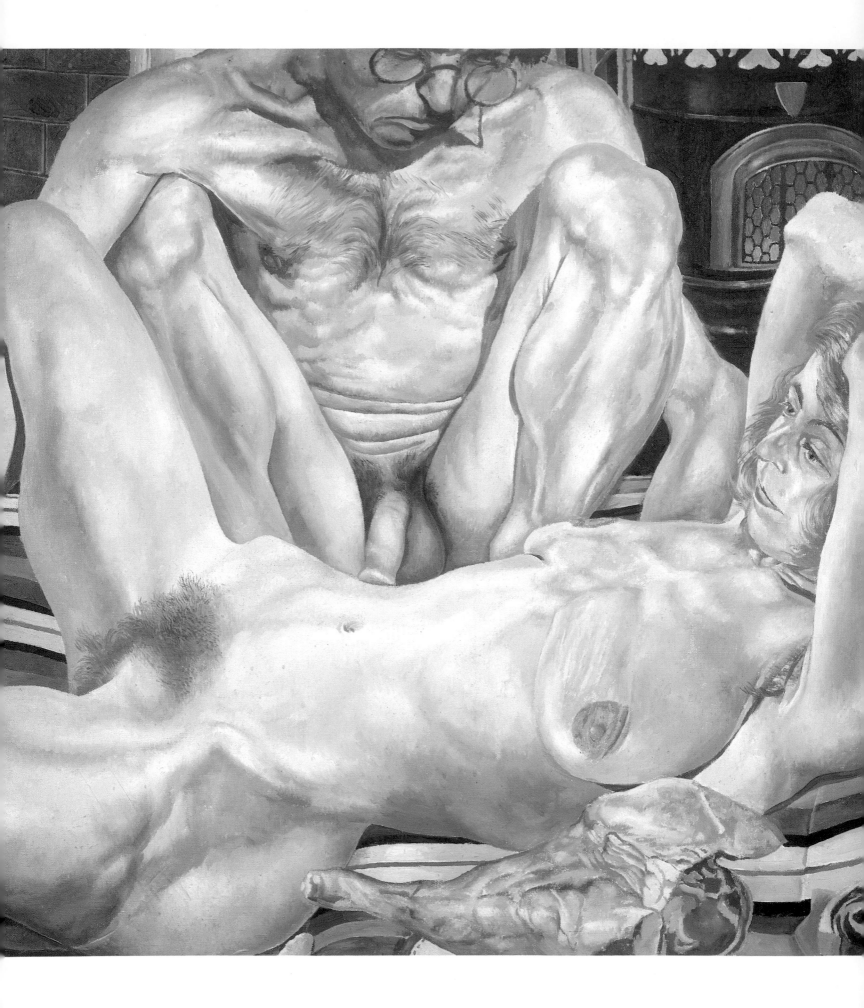

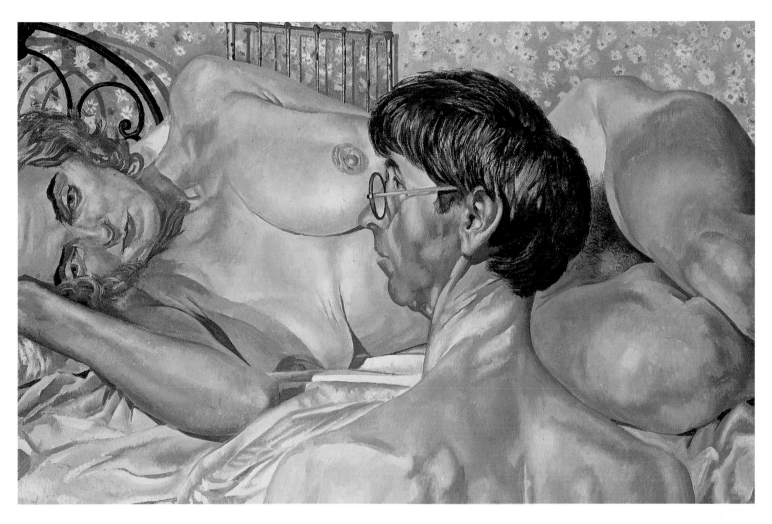

59 *Self-Portrait with Patricia Preece* (1936).
Oil on canvas, 61 × 91.2 cm (24 × 36 in).
Fitzwilliam Museum, Cambridge

58 *The Leg of Mutton Nude* (1937).
Oil on canvas, 91.5 × 93.5 cm (36 × 36⅞ in).
Tate Gallery, London

more tolerant form of Christianity, Spencer discovered William Blake, whose *Songs of Innocence and Experience* seemed to anticipate his own spiritual development:

> I went to the Garden of Love
> And saw what I never had seen:
> A Chapel was built in the midst,
> Where I used to play on the green.

Spencer's answer to 'The Garden of Love' was clear; he would build his own Chapel 'where I used to play on the green.' With his joyful scenes of Resurrection in Cookham churchyard, he had already united Blake's opposing images of tomb-stones and flowers. In *Love among the Nations* he went on to challenge the threat identified by the visionary poet as 'binding with briars my joys and desires.'

Spencer could not have chosen terms closer to Blake's assertion that 'the Religions of all Nations are derived from each Nation's different reception of the Poetic Genius, which is everywhere called the Spirit of Prophecy.'[25] Like Blake, he began to feel that *All Religions are One*, and with the opportunities available to him in the twentieth century, he was able to continue his exploration of cultures different from his own. The sometime 'Neo-Primitive' had read Sir Edwin Arnold's *Light of Asia* in Hampstead in the 1920s. Much later, he recalled in a letter to Hilda: 'I often think of us looking at the books on Indian sculpture. They seem to give me longings greater than those inspired by the Bible.'[26] Clearly, Spencer was stirred by the eroticism he found in oriental art, which confirmed for him his belief that 'desire is the essence of all that is holy.'[27]

His contemporary Eric Gill would have agreed. In his sculpture and book illustration, Gill sought to free Christianity from what he saw as its puritanical legacy of self-denial. He too was inspired by oriental sculpture to touch his religious subjects with the wand of Eros. Jacob Epstein, another early convert to the power of primitive art, continued during the 1930s to carve figures which were both spiritually and physically provocative. In the popular press he fared no better than Spencer, but at a different level of discourse both of them could take comfort from the assertions of a young critic emerging as a champion of *Art Now*. In 1933 Herbert Read wrote of art in primitive societies as having 'nothing to do with polite culture or intelligence. In its origins it is an exercise or activity of the senses, the plastic expression of elementary intuitions.'[28] The point had already been made or demonstrated in D. H. Lawrence's work *Women in Love*, published in 1921. In the chapter called 'Totem,' the attention of the characters is focussed upon a carving from the Pacific Islands of a woman in labour.

'But you can't call it *high* art,' said Gerald.

'High! There are centuries and hundreds of centuries of development in a straight line, behind that carving, it is an awful pitch of culture, of a definite sort.'

'What culture?' Gerald asked, in opposition. He hated the sheer barbaric thing.

'Pure culture in sensation, culture in the physical consciousness, really ultimate *physical* consciousness, mindless, utterly sensual. It is so sensual as to be final, supreme.'[29]

Throughout his career Spencer turned to the self-portrait as a means of self-expression. Of them all, the one he painted in 1936 [pl. 60] is the most confident, to the point of defiance. It portrays Read's primitive artist, 'the inspired oracle, the intermediary through whom the tribe secures fertility

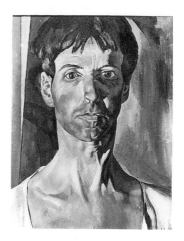

60 *Self-Portrait* (1936). Oil on canvas, 61.5 × 46 cm (24¼ × 18 in). Stedelijk Museum, Amsterdam

for their crops or success for their hunters.'[30] With its close range and unflinching eye for detail, it introduces the series of pictures Spencer painted 1935–37 for which he and Patricia Preece served as the models. Of these the *Nude (Patricia Preece)* of 1935 is one of the earliest. On one level it invites comparison with the work of Mark Gertler and Matthew Smith (or, through Smith, with his Parisian mentor, Matisse). But unlike each of those artists, Spencer did not make a habit of drawing or painting studio *Odalisques*. By definition his were portraits of an intimate and autobiographical kind. His fascination with the body of his lover left almost no room for her head at the top right of the canvas. As he explained in a later comment on the picture, 'the head does not properly belong to the body. I was trying to squeeze it into a 20 x 30 ins.'[31] On the other hand, the specificity with which he painted the contours of her flesh included the careful detail of a surgical scar, presumably the result of an appendectomy.

It was by an obvious extension of the same principle that Spencer included himself in the nudes which followed. The *Self-portrait with Patricia Preece* [pl. 59] confirms the intimacy which had to exist for Spencer to paint his subject at such close quarters. Their figures almost touch; he described how in painting them he felt like an ant, crawling over every detail of the bodies. *The Leg of Mutton Nude* [pl. 58] is so called because of the joint of meat Spencer chose to add to this most physically explicit yet psychologically complex of the series. He referred to it as his *Double Nude and Stove*, a title which draws attention to the detail in the upper right of an enclosed, brightly burning flame. The analogy with the artist-sitter's pose, which is one of absorbed concentration as he stares down at the object of his desire, is too compelling to be accidental. Both figures are sexually exposed to a point which made it impossible for Spencer to exhibit the painting at the time without fear of criminal prosecution under the laws against public obscenity. Yet he referred with disarming simplicity only to the fact that 'there is in it male, female and animal flesh. The remarkable thing is that to me it is absorbing and restful to look at.'[32] That leaves much unstated. The comparison between the neatly butchered leg of mutton and Patricia Preece's thigh to which it is adjacent or to Spencer's own left leg above it is, to say the least, disconcerting.

It is worth remembering that, the year before Spencer painted this picture, there was an important International Surrealist Exhibition in London. Once again, individual though Spencer's contributions remain, they cannot be divorced entirely from their context in the Europe of the 1930s. As Andrew Causey has pointed out,[33] there are parallels between the realism of Spencer's intimate portraits and the work of artists of the Neue Sachlichkeit in Germany. Christian Schad, for instance, painted a self-portrait in 1927 seated in front of a reclining female nude.[34] The sense of discomfort which so many of his sharply focussed figure paintings evoke is heightened further in this case by the slit and laced skin of the subject's upper torso. Like Spencer's still life from the butcher's shop, Schad's self-exposure is tinged with ambiguity.

The question of foreign contacts is raised once more by another series of paintings upon which Spencer embarked in 1937. His *Beatitudes of Love* address the issue of physical and spiritual union between the sexes. In painting them, Spencer eschewed his usual practice of identifying the figures with specific settings and painted them instead against neutral, or non-existent backgrounds. He distorted the figures to express the idea that in their love they accommodated one another physically: 'She is going to give herself to him so that parts of her flesh become parts of his flesh every day,' he wrote of the Hilda-like women exemplifying *Passion or Desire* [pl. 51]. About *Contemplation* (private

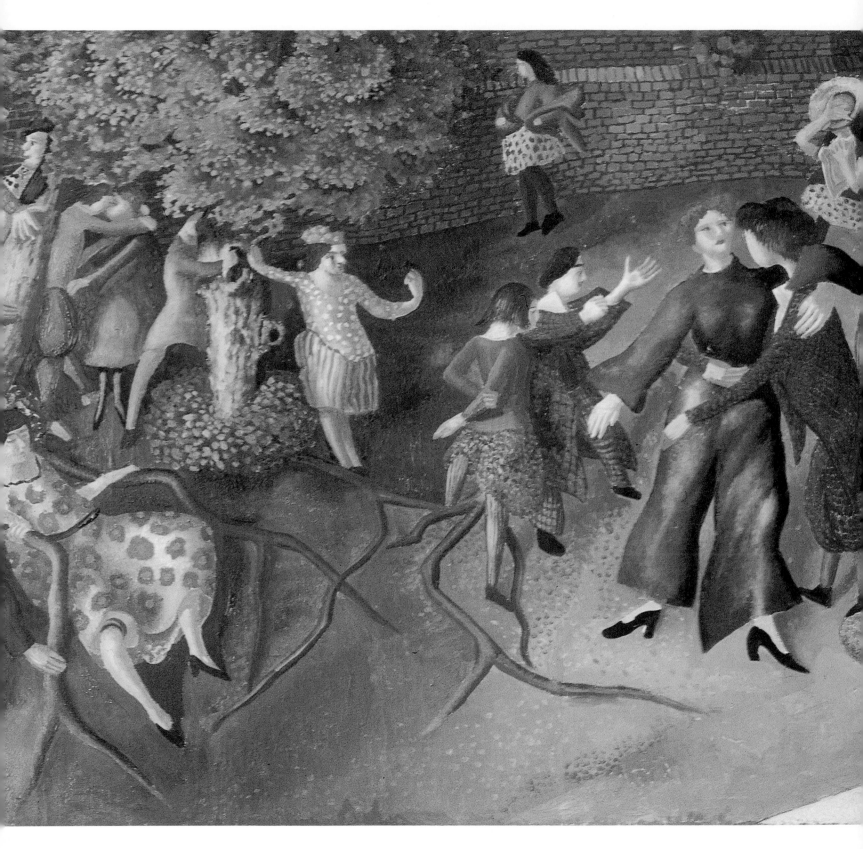

61 *A Celebration of Love in Heaven*, detail (1937).
Oil on canvas, 45.7 × 182.9 cm (18 × 72 in).
City Art Gallery, Manchester

collection) he wrote, 'they fit on to or against each other as if they were two parts or two organs of one body. They seem to find their place of rest where they can best serve each other in the same way as a liver will adapt itself to the shape of a stomach and so on.'[35]

By the extent to which Spencer pursued expressive distortion, he distanced himself from his supporters and patrons. When Sir Edward Marsh visited Tooth's Gallery to see the *Beatitudes*, they 'fogged his monocle. He had to keep wiping it and having another go. "Oh Stanley, are people really like that?" I said. "What's the matter with them? They're all right, aren't they?" "Terrible, terrible, Stanley." Poor Eddie.'[36] In British art of the period there is no parallel, although Max Beckmann's *Dance-bar in Baden-Baden* of 1923[37] offers a telling comparison. The links are tenuous, but Beckmann, who was seven years older than Spencer, was another exhibitor at the Carnegie Internationals (his *Self-Portrait in a Tuxedo* was awarded a prize in 1927), and during the 1930s he and his fellow Expressionists began to attract belated attention in England. Here too Herbert Read's book of 1933 was important. Of Expressionism in general he wrote that 'this is not a group in the conscious, organised sense. It consists of three or four artists who have in common a certain relentless realism – even a cynicism – which is partly a social protest, but a protest intensified by the experience of war. The artists I am referring to – Max Beckmann, Otto Dix, George Grosz – were all born

62 *Sunflower and Dog Worship* (1937). Oil on canvas, 69.8 × 105.4 cm (27½ × 41½ in). Private collection

around 1890. They have all painted war pictures of a grimness unequalled by anything in other countries.'[38] If he read them, those sentences would have had a certain resonance for Spencer. Finally, with their suppression by the Nazis and the purge of 'Degenerate Art' from German museums in 1937, the Expressionists and their work travelled westwards. In 1938 the comprehensive exhibition of Modern German Art at the New Burlington Galleries was featured and illustrated in *The Studio*.[39]

By then Spencer faced an exile of his own. Divorce from his first wife became absolute on 24 May 1937. Five days later his marriage to Patricia Preece was registered at the Town Hall in Maidenhead. But he regarded neither act as legally binding, and in his attempts to retain the attentions of two wives he succeeded only in losing both. The second Mrs Spencer retreated quickly to her own cottage of Moor Thatch, leaving her husband, temporarily at least, to the care of the faithful Elsie at Lindworth.

There, in the second half of the year, he embarked with perverse vigour upon the next stage of his Church–house scheme. 'A church and a house combined would perfectly fit the mixture,' he noted in a paper written in 1937.[40] He envisaged a site on which a church would be flanked by two 'private houses' (shades of the almshouses at Burghclere) and a series of small chapels, each eight feet square. 'Along the church aisle would be twelve chapels for the contemplation of married happiness, each chapel, like a cubicle, to contain pictures of couples in the style of the *Beatitudes of Love*.' For the nave of the church, he painted *A Celebration of Love in Heaven* [pl. 61], an eternal *Kermesse* set predictably on the edge of Cookham Moor beside the War Memorial, which Spencer converted into an altar to Priapus. Local conventions may have provided the cue; it was a favourite spot for assignations among the villagers. But for Spencer it provided a *locus classicus* for amorous encounters of every age and kind. Unbridled love once again provided the answer to all life's problems, in theory at least, on his proverbial doorstep.

In *Sunflower and Dog Worship* [pl. 62] he extended that principle to the animal and vegetable kingdoms. 'A husband and wife make love to the sunflowers in their own gardens,' he explained. 'The husband holds his wife's bag so she can do it better.'[41] Informed by his knowledge of the cult of Asparsas, this picture carried Spencer's sexual evangelism to its furthest point: 'the mystery of love is that it can find its abode in something not meant for itself, and yet when it does so, it is clearly its home.'[42] Isolated but unrepentant, Spencer experienced a period of creativity which rivalled his prewar days. But the threat which menaced his new faith was not the external one of international politics (although that existed too); it was the insistence of Patricia Spencer that he could no longer afford to live at Lindworth. In 1938 the native once more packed his bags in what amounted to a second Expulsion from the Garden of Eden.

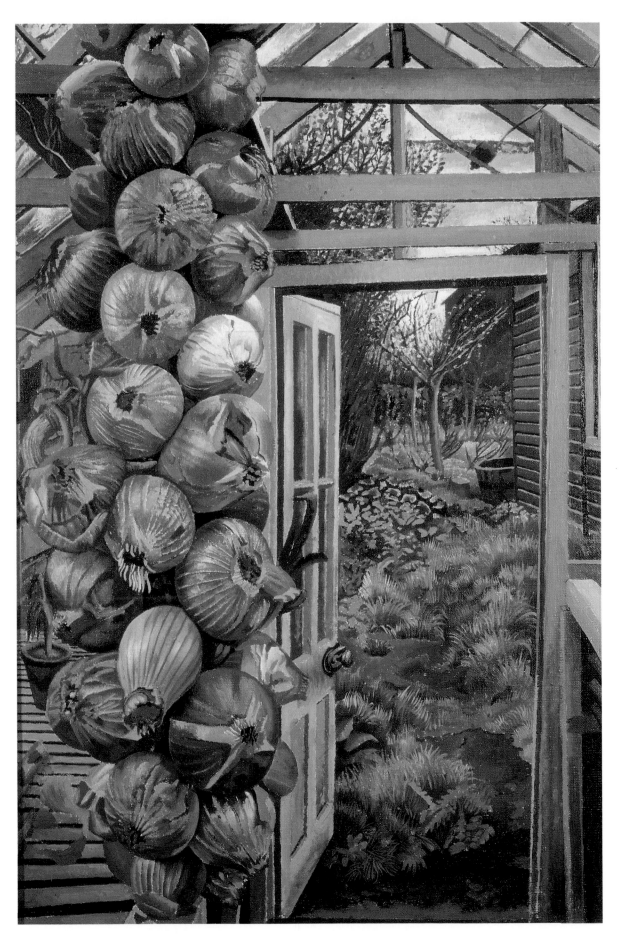

63 *Greenhouse and Garden*
(1937). Oil on canvas,
76.2 × 50.8 cm (30 × 20 in).
Ferens Art Gallery: Hull
City Museums and Art
Galleries

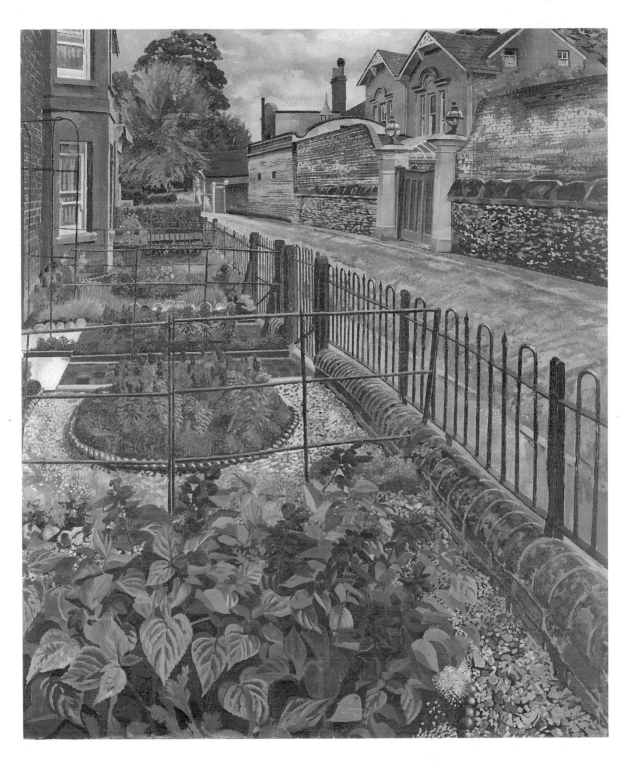

64 *Gardens in the Pound, Cookham* (1936).
Oil on canvas, 91.4 × 76.2 cm (36 × 30 in).
Leeds City Art Galleries

Exile 5

Not that Spencer was entirely unhappy when faced by the prospect of a move. By the summer of 1938 he had lived alone at Lindworth for more than a year. He had painted for long hours and with extraordinary concentration, even by his own standards. His Adorations and Beatitudes were overtly sexual sermons in paint, attempts to justify his faith in universal love. At another level they were compensatory for the personal failure Spencer experienced with his two wives. He turned instinctively to his art for the fulfillment which life denied.

In the same year he also painted some forty landscapes, canvases for which Dudley Tooth had no difficulty in finding a ready market. Spencer resented the pressure, but with two wives and two children to support, he needed the money his dealer was prepared to advance against future sales. And in spite of himself, he could not fail to do justice to Cookham and its surrounding countryside. *Gardens in the Pound, Cookham* [pl. 64] dates from 1936. As Elizabeth Rothenstein wrote, 'he could paint semi-detached houses and suburban front gardens with an exaltation and pride that a century earlier had gone into paintings of Tivoli and the Campagna.'[1] In their own way they were equally idealized, their neat horticultural boundaries representing the kind of domestic order which was absent from Spencer's own turbulent life.

He painted *Cookham Moor* [pl. 71] in the late spring of 1937, at the time of his second marriage. A view along the road across the moor, it includes on the right Moor Thatch, the cottage in which Dorothy Hepworth and Patricia Preece lived. That in itself cannot have been without significance for the painter. From his implied position, looking eastwards with his back to Cookham Rise, the causeway runs without incident or interruption towards the crossroads at the foot of the War Memorial (already established in Spencer's iconography as Cookham's altar of love). Appropriately, the sunlight which falls on the right of the cross carries the eye around the corner and points along the thin but gleaming strip of road towards Moor Thatch. Between the paths Spencer painted one of his most softly textured landscapes, lush with mossy greens and the pink of summer sedge. In the distance the darker tones of woodland form a protective enclosure around the west end of the village, as it nestles forever undisturbed in a pool of late afternoon sunlight. The conclusion is unavoidable that landscape painting could, on occasion, satisfy a need for Spencer beyond that of earning a living.

The *Landscape in North Wales* of 1938 [pl. 65] is another example. Like the poet Vernon Watkins, Spencer found 'Peace in the Welsh Hills':

> Calm is the landscape when the storm has passed.
> Brighter than the fields, and fresh with fallen rain.[2]

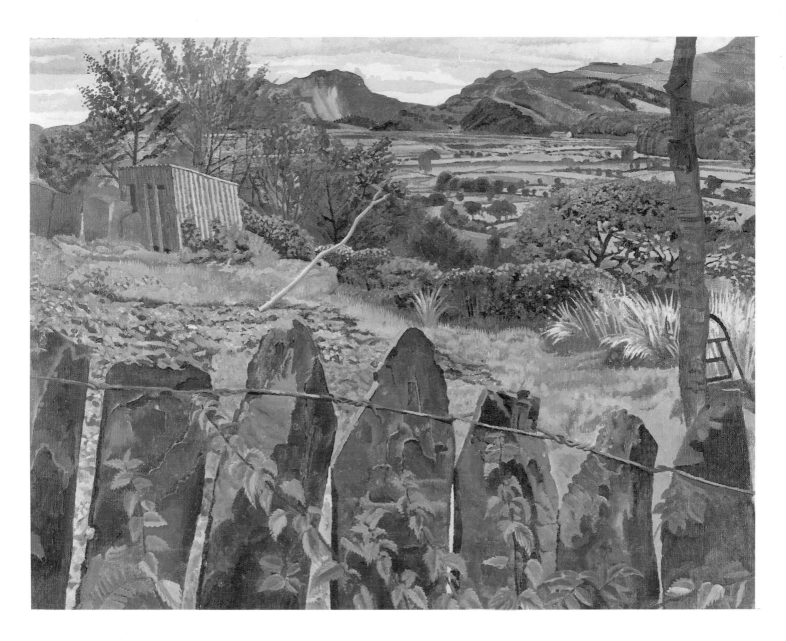

65 *Landscape in North Wales*
(1938). Oil on canvas,
55.9 × 70.8 cm (22 × 27⅞ in).
Fitzwilliam Museum, Cambridge

Once again, his response to nature was tempered and strengthened by human relationships. He painted the picture while he was staying with his former wife and her mother, Mrs Carline, in a house which they had borrowed from a friend in Snowdonia. Spencer joined them there for several weeks at the end of the summer and responded at once to his surroundings with a fresh burst of poetic naturalism. The spot he chose to paint is, in the foreground at least, characteristically enclosed, a kind of rural equivalent to the *Gardens in the Pound*, defined by means of the rough-hewn slate fences within which there are signs of cultivation of sorts, old outbuildings and other careless references to human intervention.

It is a measure of the Carlines' tolerance and affection that Spencer continued to stay with them after his divorce. In August 1937 he spent several weeks at the family house in Hampstead and painted there his portrait of *Hilda, Unity and Dolls* (Leeds City Art Galleries). A year later, after his visit to north Wales, he returned briefly to Cookham before leaving Lindworth for good. From there he gravitated towards Hampstead again, staying at first with his friends the Rothensteins in

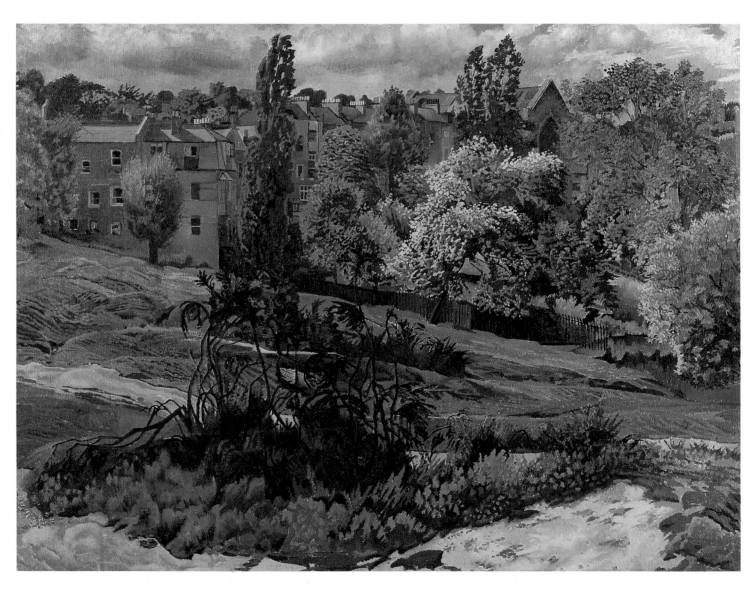

66 *The Vale of Health, Hampstead* (1939).
Oil on canvas, 60.9 × 81.3 cm (24 × 32 in).
Glasgow Art Gallery and Museum

67 *Daphne* (1940).
Oil on canvas, 51 × 61 cm (20 × 24 in).
Tate Gallery, London

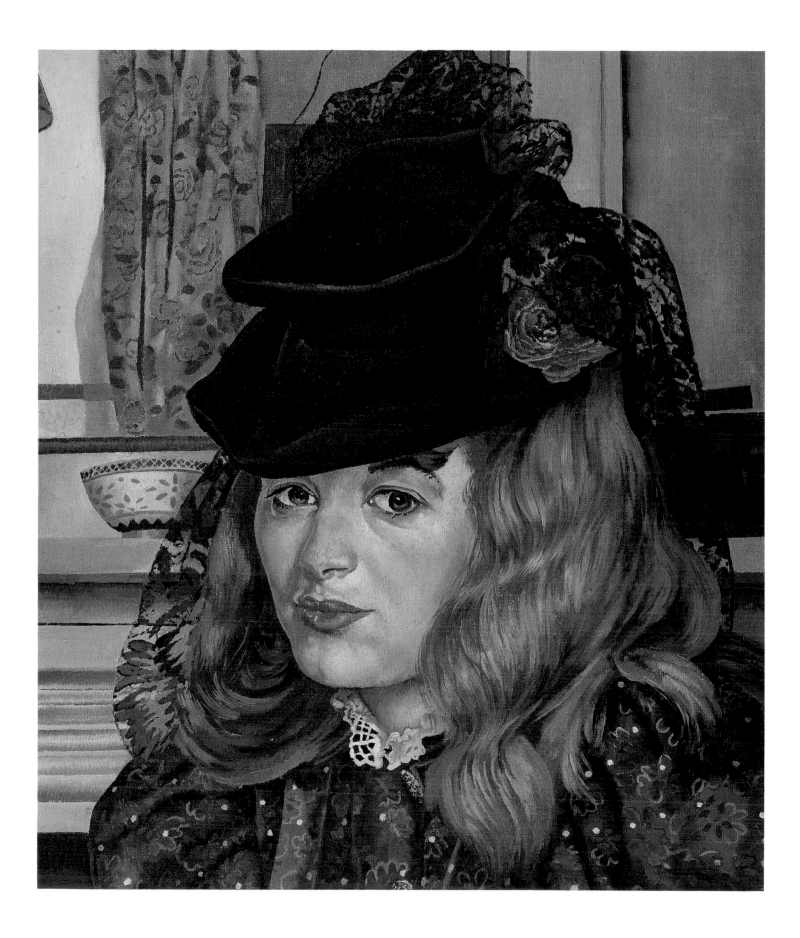

Swiss Cottage. By the end of the year he had moved into an attic room at 188 Adelaide Road, within walking distance of their house in one direction and of Pond Street and Hampstead Heath in the other.

Thus installed, Spencer deliberately isolated himself for the first three months of 1939. 'Alone here I felt that I could sort myself out,' he admitted. 'After sweeping the floor and dusting a bit, I would sit down on one of the two chairs and think and look at the floor. Oh, the joy of just that!'[3] Thanks to Dudley Tooth, he was spared further financial problems. With the ownership of Lindworth, Patricia Spencer took over responsibility for its maintenance. Spencer's material world shrank into a small bare room. And as he took stock of the past several years, he came to the conclusion that his figure paintings since 1932 had 'drawn me too much one way.'[4]

He returned to the Bible for fresh inspiration and began a remarkable series of small paintings, each as autobiographical as any of Spencer's works, of *Christ in the Wilderness*. Originally he planned forty separate canvases, one for each day Christ spent alone in the desert. In his own retreat Spencer completed the first four, including *The Scorpion* [pl. 68]. In each the figure of Christ is reminiscent of his early figure style: a simple massive human form filling the picture plane. Whether cupping an insect in his hands or kneeling to consider the lilies, Christ is portrayed in meditation, a study in introspection with which Spencer readily identified. In a later diary entry he compared 'the great adventure that Christ had all by himself with leaves, trees, mud and rabbits' with his own experience

68 *Christ in the Wilderness: The Scorpion* (1939). Oil on canvas, 56 × 56 cm (22 × 22 in). The Art Gallery of Western Australia, Perth

69 *Christ in the Wilderness: Rising from Sleep in the Morning* (1940). Oil on canvas, 56 × 56 cm (22 × 22 in). Private collection

in Adelaide Road 'among two chairs, a bed, a fireplace and a table . . . I was as it were in a wilderness.'[5] *Rising from Sleep in the Morning* [pl. 69] was painted a year later, in 1940, but it gives visual expression to the transcendental nature of Spencer's spiritual experience. 'I felt there was something wonderful in the life I was living . . . penetrating into the unknown me . . . I loved it all because it was God and me all the time.'[6]

Spencer emerged from isolation to bask in a new-found friendship. Daphne and George Charlton were younger artists than Spencer, both Slade-trained and sympathetic. He met Daphne Charlton first at a party given by Nevinson and was literally lured out of seclusion by her warmth and friendship.

70 *Chopping Wood in the Coal Cellar: Elsie* (1944–45). Pencil on paper, 40.6 × 28 cm (16 × 11 in) approx. Private collection

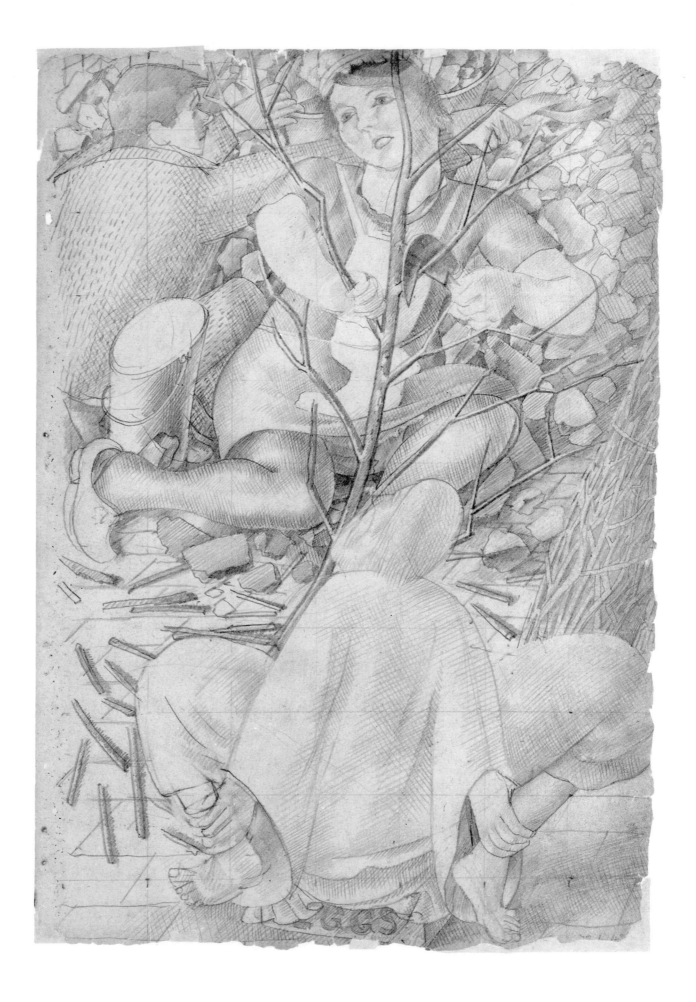

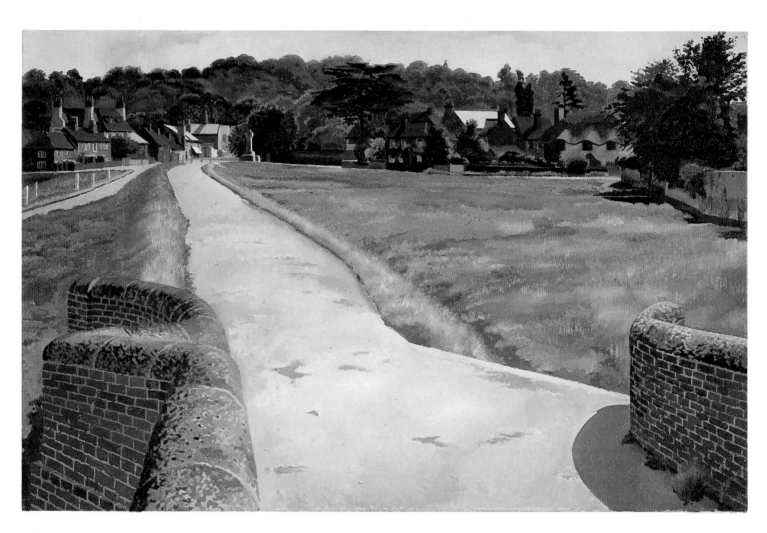

71 *Cookham Moor* (1937).
Oil on canvas, 49.5 × 75.6 cm (19½ × 29¾ in).
City Art Gallery, Manchester

72 *Village Life, Gloucestershire* (1940).
Oil on canvas, 79.4 × 111.8 cm (34¼ × 44 in).
Cheltenham Art Gallery and Museums

Once again, a landscape painting marks the significance of the event; Spencer painted *The Vale of Health, Hampstead* [pl. 66] while he was staying with the Charltons at 40 New End Square. It was, of course, familiar territory. He and his former wife had worked in the Vale of Health from 1923 to 1927, in the studio which belonged to Henry Lamb. The landscape of 1939 was therefore charged with past association as well as with present opportunity. Here too Spencer set out to convey the significance of place in his life. The careful detail and delicate naturalism with which he portrayed London's northern boundary, where city and countryside merged, are symptomatic of his own heightened sense of awareness as he emerged from the attic in Adelaide Road. He did so brush in hand, as in the *Self-Portrait* painted at the time (Fitzwilliam Museum, Cambridge), no longer the fiery evangelist of three years earlier but a firmly bespectacled professional wearing coat, collar and tie as he gazes intently over a well loaded palette at his favourite subject – himself. Both paintings, the landscape and the portrait, are reaffirmations of faith: of Spencer's faith in the discipline of his art to create order out of the chaos of his life.

In the summer of 1939 the Charltons took Spencer with them to stay at the White Hart Inn in the village of Leonard Stanley in Gloucestershire. There too, he flourished in their company, no doubt flattered by the attention of an attractive and intelligent younger woman who was prepared to listen with sympathy to his problems and nurse his bruised talents back to their full vigour. In 1940 he painted his tribute, the *Portrait of Daphne* now in the Tate Gallery [pl. 67].

Meanwhile, from the stationers in Leonard Stanley, he bought four scrapbooks, or albums of 'Derwent' paper, in which he began to draw the recollections of a lifetime. Among the earliest, *Gladiator at the Technical School, Maidenhead* provides an amusing reminiscence of the artist's earliest training: 'And like the comic postcard I saw of two tramps saying to each other about a cow in a field. Just think everywhere it looks it sees something to eat, so here everywhere one looked there was something to draw or being drawn.'[7] Others, like the *Domestic Scenes* of 1936, concentrated upon the daily rounds at Fernlea, Chapel View and Lindworth. They did so in the same spirit of recovery: 'When I am composing these ordinary scenes I am seeing them in this redeemed and after resurrection and Last Day state.'[8] Thus in the drawing of *Chopping Wood in the Coal Cellar* [pl. 70] the figures of Spencer and Elsie are joined by a squatting patriarch, a benign prophet or 'divine presence,' as Blake would have put it.

For years to follow the scrapbook drawings provided Spencer with subjects for his oils. In the ideal scheme of the Church–house, he conceived of them as decorations for four 'chapels,' each one dedicated to a different idol: Hilda Carline, Patricia Preece, Elsie Munday and Daphne Charlton. He lost no time in painting *The Woolshop* (private collection) for his shrine to Daphne, assuming for himself the doubly subservient roles of shop assistant and assistant to the shopper. A decidedly youthful Spencer is engrossed and engulfed in the skeins of wool which bind him like giant umbilical cords to the latest of his *Erdmuttern*. It is an energetic painting, a masterpiece of inventive design, painted in deliberately bright colours, and a further sign of Spencer's spiritual recovery.

Village Life, Gloucestershire [pl. 72] reinforces the point, with a fully developed subject picture in which Leonard Stanley is placed on a par with Cookham as a sacred grove. In the painting 'an old couple witness ... the coming of God in the sky while they and a grandchild were in their garden taking in the clothes.'[9] They do so in the presence of Daphne Charlton and both Stanley and Hilda Spencer. In fact, the composition comes perilously close to identifying Daphne as the

subject of their vision; at first sight the child's pointing forefinger and her grandfather's gaze appear to be focussed upon Daphne's formidably impassive figure. The ambiguity is appropriate. The Spencers flank her, portrayed as they might have looked at least ten years earlier, a young but also somewhat disconsolate couple, Stanley facing forward, head down, on one side and Hilda looking away and also downwards on the other. The implication is clear: they too await the enlightenment which Daphne's physical presence epitomizes in the picture. For Spencer, she had come to represent the hope that he would recover not only his lost self but also the first of his wives: 'All things are redeemable in my opinion and I paint them in their redeemed state.'[10]

Port Glasgow

Twenty years after signing the Treaty of Versailles, Britain and Germany were at war again. Thanks to the success of the Official War Artists scheme during the First World War, an Advisory Committee was set up almost at once, under the chairmanship of Sir Kenneth Clark. In October 1939 Spencer wrote to Dudley Tooth, urging his dealer 'to find me a war job, some sort of official art employment.'[1] Tooth contacted Clark, and in the following January Spencer was interviewed on behalf of the committee. He offered to paint a large Crucifixion with a predella illustrating scenes from Hitler's invasion of Poland, a proposal to which the Committee's reaction was guarded. It was explained to him that the Ministry of Information would accept eye-witness accounts only of the war, and he in turn agreed to the counter-proposal that he should visit the shipbuilding yards of Port Glasgow to record the war effort there. His first expedition to Lithgow's shipyard took place in May 1940 and was an immediate success. 'I like it here,' he wrote to Hilda, 'being lost in the jungle of human beings, a rabbit in a vast rabbit warren.'[2]

In Port Glasgow Spencer's old affection for the human race was rekindled. Like Cookham, Clydeside revealed a strong sense of community; like the soldiers he fought beside in Macedonia, the shipbuilders operated under orders, a structured work force of individuals who laboured together from shift to shift like an army of ants crawling in and out of the vast steel hulks of their own constructing. But as his innumerable sketches and studies show [pl. 74], Spencer saw the workmen as individuals, whether they were hammering or drilling, welding or rivetting, or simply at ease, perched on the blade of a propeller and eating a sandwich. For the artist who had found significance in the drudgery of sluicing a hospital washroom, the concentrated activity of the men in the shipyards inspired a kind of awe: 'I was as disinclined to disturb them,' he explained, 'as I would be to disturb a service in the church.'[3]

Twice before in his career, Spencer had attempted industrial subjects. In 1929, while he was working at Burghclere, the Empire Marketing Board commissioned a series of paintings devoted to the subject of Industry and Peace.[4] Six years later, thanks to Dudley Tooth, he was asked to submit designs to decorate the interiors of the Cunard liner, the *Queen Mary*. For that, he proposed a twenty-foot mural of *Riveting*, to hang above the entrance to the ship's ballroom, so that 'out of the midst of this wealth and splendour should arise something so remote from the seas as to seem like a ghost of the past, namely the men building the ship.'[5] There was a certain aptness about Spencer's theme; the *Queen Mary* was built on the Clyde under a subsidy from the British government designed to stimulate the shipbuilding industry after the Depression. But in 1936 the Directors of the Cunard Line were not impressed by this reminder of workmen in their house.

Although Spencer never claimed any political significance for his work, he and his patrons found

74 Study for *Shipbuilding on the Clyde: Riveters* (1941). Pencil on paper, 34.3 × 48.3 cm (13½ × 19 in). Imperial War Museum, London

73 PREVIOUS PAGE: *Shipbuilding on the Clyde: Welders* (1941). Oil on canvas, triptych, left section, detail. Imperial War Museum, London

75 *Shipbuilding on the Clyde: Riggers*, detail of central section. Imperial War Museum, London

themselves on opposite sides of a growing international divide, one which widened sharply after the much publicized controversy which erupted in 1934 over Diego Rivera's mural in the Rockefeller Center in New York. At all events conservatism became the keynote of the decoration of Cunard's flagship. Spencer was not the only artist to be censored; three large panels by Duncan Grant were removed from the lounge, in spite of the fact that they had been commissioned by the architect in charge of the ship's interior design.

As abortive as both of Spencer's earlier industrial mural projects proved to be, they were important as antecedents to his wartime shipbuilding series. He admitted freely in 1936 that he had 'very little knowledge' of the shipyards.[6] Four years later he immersed himself in them and responded with all of his artistic inventiveness to the extraordinary working conditions he discovered there. By the autumn of 1940 he had completed the triptych *Burners* [pl. 78]. Its surface is alive with the contortions of the metal-workers, toiling away in eerie pools of artificial light provided by their acetylene torches as they crouch and sprawl among the steel plates. To the upper right of the central section a youthful Spencer squats, cap in hand, the only figure in the entire composition who is not wearing goggles and working. Instead, he watches with a mixture of bewilderment and wonder. Like the scenes he painted in the Burghclere Chapel and the domestic interiors of his life at Chapel View and Lindworth, Spencer's shipbuilding pictures are uncomfortably close-up. Spatial depth is kept to a minimum to replicate on canvas the cramped conditions under which the shipbuilders worked. The eye is given no escape from the noise, heat and sweat of the shop floor; the lack of perspective is deliberate, psychologically as well as visually.

76 PREVIOUS PAGE: *Shipbuilding on the Clyde: Plumbers*, detail. Imperial War Museum, London

77 PREVIOUS PAGE: *Shipbuilding on the Clyde: Riveters* (1941), detail. Oil on canvas, 76.2 × 579.2 cm (30 × 228 in). Imperial War Museum, London

78 *Shipbuilding on the Clyde: Burners* (1940). Oil on canvas, triptych, centre section 106.7 × 152.4 cm (42 × 60 in), sides each 50.8 × 203.2 cm (20 × 80 in). Imperial War Museum, London

79 BOTTOM: *Shipbuilding on the Clyde: Bending the Keel Plate* (1943). Oil on canvas, 76 × 575 cm (30 × 228 in). Imperial War Museum, London

Burners was an instant success. It was shown in October 1940 at the War Artists' Exhibition at the National Gallery in London. The Committee wrote Spencer that they were 'delighted with your first three canvases'[7] and confirmed that they wanted him to continue his eye-witness account of Port Glasgow. In *Riveters* [pl. 77] he once again revelled in the improbable shapes and angles of the men and their equipment. Figures are shown crawling in and out of steel pipes and carapace-like casings. The *Welders* (1941) [pl. 73] are further compartmentalized, each into his own steel cubicle in the central section of that triptych. The effect is that of 'belonging' to use Spencer's own word to describe that necessity he felt from childhood onwards to identify people with places: the orderlies with the Beaufort Hospital, the soldiers with their trenches, the resurrected with their graves.[8]

The analogy may seem far-fetched, but in 1943 he completed *Bending the Keelplate* [pl. 79] in which 'one looks across an intervening space in which men are respectfully preparing a plate for the machine burner, and bolting a lighter section of frame to a heavier section, to where the shoe plate in its cradle is being beaten into shape.'[9] With its horizontal format, central light source and marked division of left from right, the composition recalls nothing so much as the Last Judgement painted by Fra Angelico and now in the Museo di San Marco in Florence. That fifteenth-century master was a particular favourite of Spencer's at the outset of his career when he collected Gowans and Gray Art Books to extend his knowledge of these earlier artists whom he and his 'Neo-Primitive' friends chose to admire.[10] And thanks to his belief in the redemptive power of his art, the subject of resurrection was never far from his thoughts.

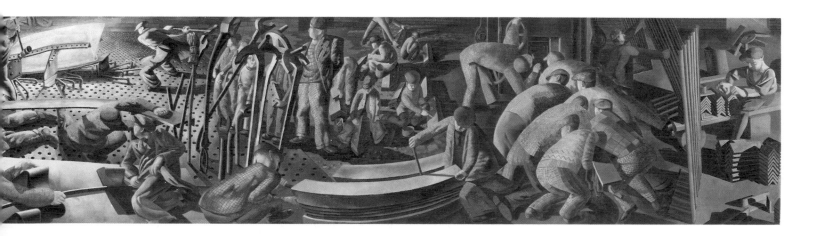

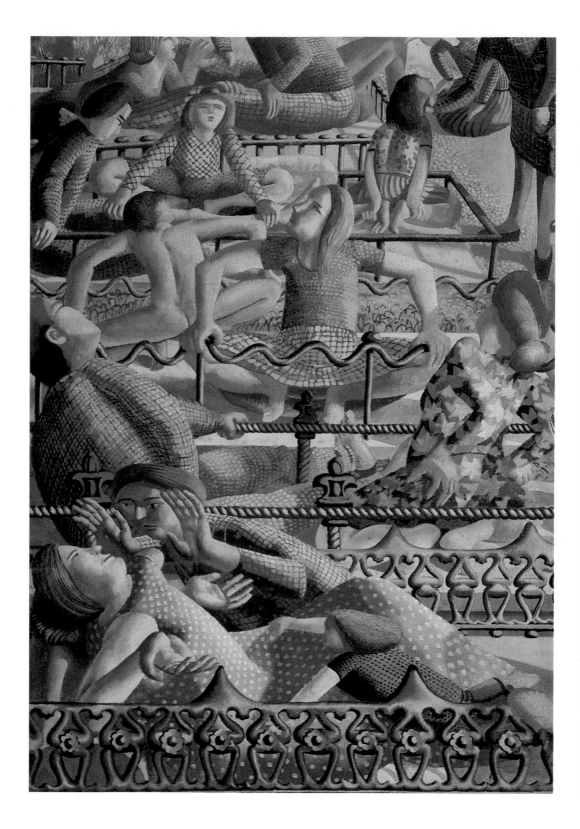

80 *The Resurrection: Reunion* (1945).
Oil on canvas, triptych, left and centre sections each 75.6 × 50.8 cm (29¾ × 20 in),
right section 76.2 × 50.1 cm (30 × 19¾ in).
Aberdeen Art Gallery and Museum

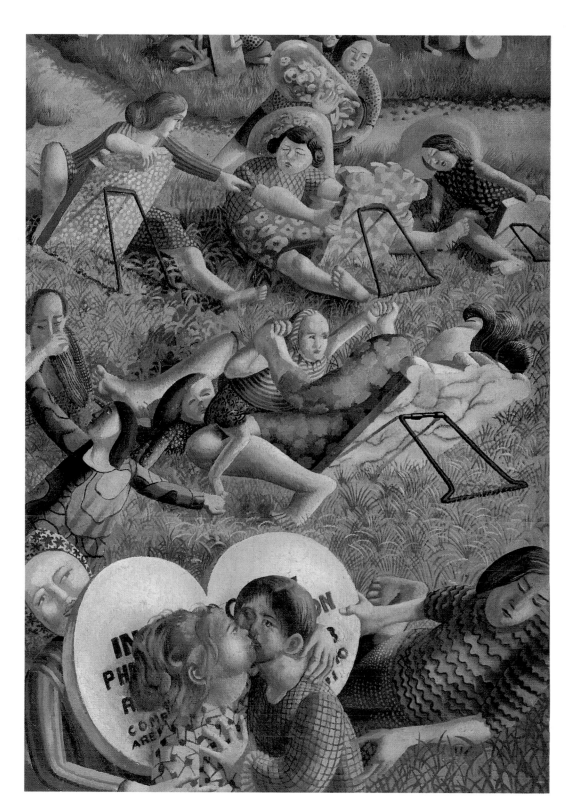

At Leonard Stanley in 1940 Spencer had begun to conceive of a painting of Resurrection 'in some suburban place or small town such as Stonehouse, and with this wish strongly felt, I saw a photograph in a house where I was lodging of a church standing at a junction of two streets. ... This actually gave me the first material for this street resurrection picture.'[11] He began the side-panels of what was to become, in 1947, *The Resurrection with the Raising of Jairus' Daughter* [pl. 81]. On the left the former inhabitants of Stonehouse rise from beneath the paving stones of the village street. In Spencerian fashion they embrace one another as a prelude to the homecoming the villagers have prepared for them. 'In order to further make clear my feeling of happiness,' Spencer explained, 'I put over the doors the usual "Welcome Home" signs and flags and bunting they put up for the soldiers returning from the war.'[12] In the right-hand panel the dead are shown returning from their graves in the churchyard to the gates of their former houses in the village. Prominently in the foreground, Stanley and Hilda Spencer figure among those blessed with eternal reunion. There is a continuity of space between the central panel and its wings. Through the glazing bars of a simple sash window the viewer looks in upon the New Testament miracle for which the triptych is named. Like *The Centurion's Servant*, it is a 'bed picture,' more explicit in its biblical detail but no less reminiscent of those childhood visions which Spencer associated with the rooms in Fernlea.

The central section, the *Raising* itself, was designed in Port Glasgow, the next-in-line of Spencer's new Jerusalems. From 1940 onwards he stayed for periods of a month or so at a time at Glencairn, a local boarding house. As an Official War Artist he had to have naval rank, which in his case was that of Ordinary Seaman, carrying few privileges beyond access to the shipyards. On one occasion he appealed to Dudley Tooth to intervene on his behalf: 'I am far more exposed to the weather than a great many people, whether soldiers or sailors or the civil defence. I have a three-mile walk daily in the rain. Not in any of my visits to Scotland have I known what it was to walk in boots that did not leak.'[13] On the other hand, he delighted in temporary membership in a solid working-class community.

81 *The Resurrection with the Raising of Jairus' Daughter* (1947). Oil on canvas, triptych, centre section 76.8 × 88.3 cm (30¼ × 34¾ in), sides each 76.8 × 51.4 cm (30¼ × 20¼ in). Southampton Art Gallery

It was inevitable, under such circumstances, that he began to devise a pictorial scheme to honour his new neighbours. His official commissions commemorated their heroic efforts at work, no less than the sidewalls of the Sandham Memorial Chapel detailed the lives of soldiers in the First World War. Both series of eye-witness accounts express the deep respect and affection Spencer felt for his subjects. Both evidence his identification with them, and finally, both anticipate his effort to transcend reality by means of a redemptive vision. It is important to recall that the first image Spencer proposed in response to his wartime commission was that of a Crucifixion as a symbol of current human oppression. Diverted from that by the terms of his employment as an Official War Artist, he was, none the less, bound by his own artistic agenda to consider the spiritual dimensions of his task. And so, in his own words, 'one evening in Port Glasgow, when unable to write due to a jazz band playing in the drawing-room just below me, I walked up along the road past the gas works to where I saw a cemetery on a gently rising slope [pl. 83] ... I seemed then to see that it rose in the midst of a great plain and that all in the plain were resurrecting and moving towards it ... I knew then that the Resurrection would be directed from this hill.'[14]

The overall theme for the Port Glasgow Resurrections is established in one of the earliest, *Reunion* of 1945 [pl. 80]. In it Spencer explained, 'I have tried to suggest the circumstances of the Resurrection through a harmony between the quick and the dead, between the visitors to the cemetery and the dead now rising from it. These visitors are in the central panel, and the resurrected are in the panels right and left.'[15] In the left panel the graves are defined by means of railings: neat rows of sepulchral wrought iron that divide the space into those cozy cubicles that Spencer loved. For him, they symbolized both the cradle and the grave, with a deliberate reminiscence of suburbia: 'Here I had the feeling,' he wrote, 'that each grave forms a part of a person's home just as their front gardens do, so that a row of graves and a row of cottage gardens have much the same meaning for me. Also although the people are adult or any age, I think of them in cribs or prams or mangers ... "Grown-ups in prams" would express what I was after.'[16] He painted himself and his two wives as beneficiaries of this distinctly optimistic view of eternity, in marked contrast to the sad facts of his actual relationships with both. As Hilda Spencer succumbed to mental illness, he sought in his art and in the incessant correspondence he maintained with her reunion of a personal kind.

Once the idea for the Port Glasgow Resurrections took hold, it developed into a scheme in Spencer's mind no less ambitious than the Sandham Memorial Chapel or the Church-house project. He worked on the series intermittently between 1945 and 1950, completing eighteen canvases in all, twelve of them designed and executed as four independent triptychs. The largest single painting, *The Resurrection: Port Glasgow* [pl. 85], was also supposed to be the centre of a three-part vertical composition, with *The Hill of Zion* (Harris Museum and Art Gallery, Preston) and *Angels of the Apocalypse* (private collection) above it. However, the scale of the two pendants differs markedly, as if from the outset Spencer abandoned as unrealistic the idea of keeping the components together; they were, in fact, sold separately.

There were doctrinal reasons, also, for the separation of the work. The subject of the seven *Angels of the Apocalypse* gave Spencer some difficulty. In the Book of Revelation they are the agents of divine retribution who 'pour out the seven bowls of the wrath of God onto the earth,'[17] a notion entirely at odds with Spencer's benign vision of the Last Judgement. 'I wanted,' he explained to Dudley Tooth in 1949, 'some measure of mercy and so hoped it could be thought that some less

82 *The Clyde from Port Glasgow*
(1945). Oil on canvas,
50.8 × 76.2 cm (20 × 30 in). Yale
Center for British Art, New Haven,
Connecticut

83 *Port Glasgow Cemetery* (1947).
Oil on canvas, 50 × 76.2 cm
(20 × 30 in). The British Council

84 *At the Piano* (1957). Oil on
canvas, 91.5 × 61 cm (36 × 24 in).
Private collection

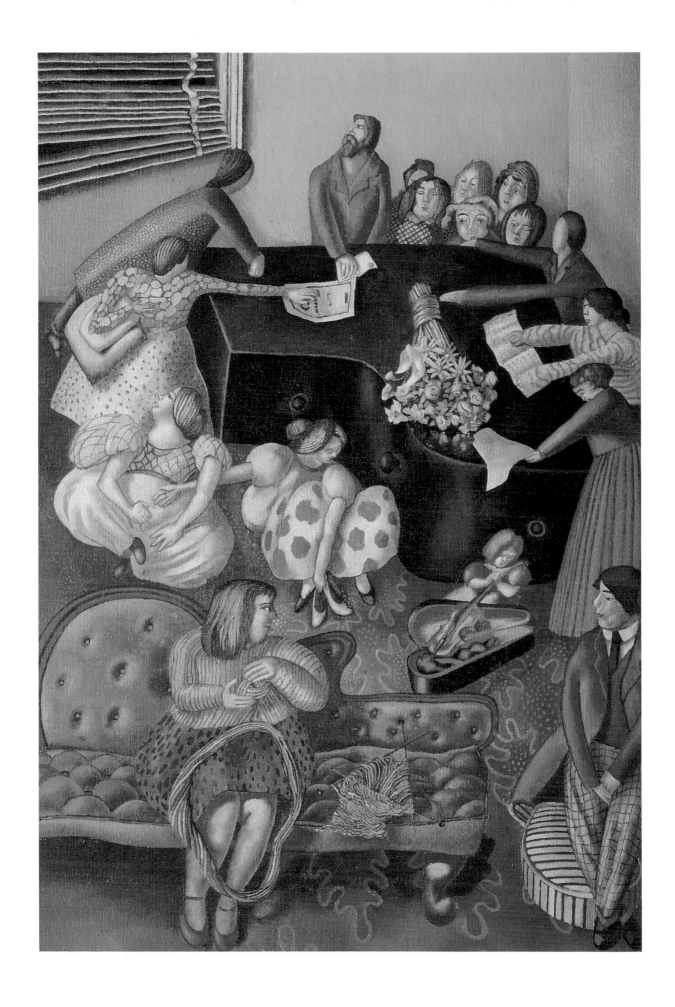

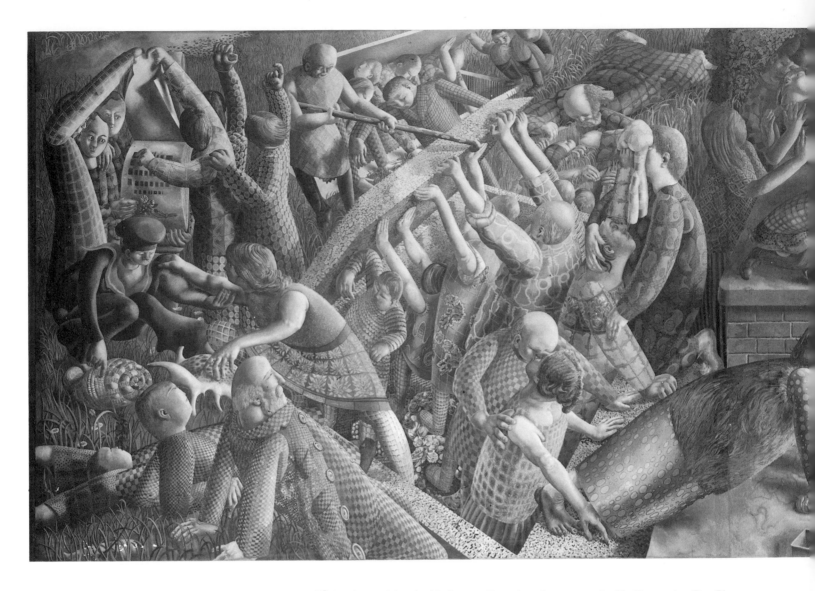

potent poison was being poured on the wrongdoers.'[18] In the end he decided to realign the picture with the Book of Genesis, to make it 'one of the few compositions I have done of the Creation, this being angels assisting God in fertilising the earth with distributory seeds.'[19]

The Resurrection itself is comparable in scale to Spencer's treatment of the same subject a quarter of a century earlier, and like the Cookham *Resurrection* it marks a turning point in his career. In the earlier picture he paid respects to Cookham as the seat of his vision. He also acknowledged a succession of debts of a personal and of an artistic kind: to the Carlines, the Slade and his own brand of Neo-Primitivism. Twenty-four years later Port Glasgow offered him a similar pretext for self-assessment. Keith Bell has pointed to the contrast between the earlier and later paintings of the *Resurrection*.[20] That of 1950 is a more frenzied composition, full of exaggerated gestures and anatomical distortions. As such, it recalls the subject pictures of the 1930s, *The Dustman or The Lovers*, *Love among the Nations* and the *Adorations*. The surface is filled with outstretched arms and upturned gazes in yet another celebration of union and reunion. The sexual implications remain,

85 *The Resurrection: Port Glasgow* (1947–50). Oil on canvas, 215 × 665 cm (84½ × 262 in). Tate Gallery, London

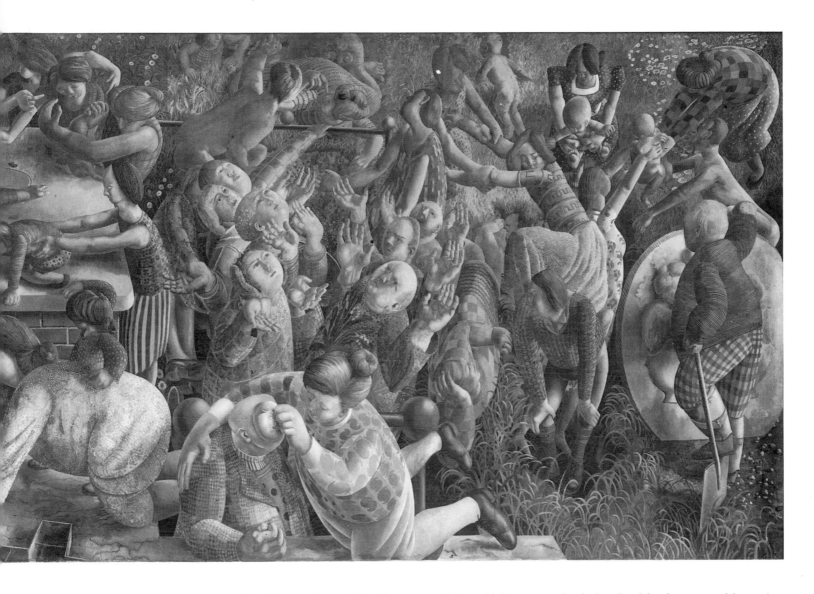

but they are less strident in a composition which equates physical and spiritual ecstasy without that old fervour for the flesh.

With similar discretion Spencer concealed within the canvas the portrait of the married woman he met in Glasgow during the winter of 1943–44 and who transformed his life there. With their circle of talented friends, she and her husband provided a congenial setting for Spencer's later visits to Scotland. *At the Piano* [pl. 84] is just one of the paintings in which he referred to the musical evenings he enjoyed at their flat in Crown Circus. Given her importance for Spencer at the time, it was impossible for him to omit her from this latest litany, in which past and present were woven, like so many of the painted figures, into a seamless garment of redemption.

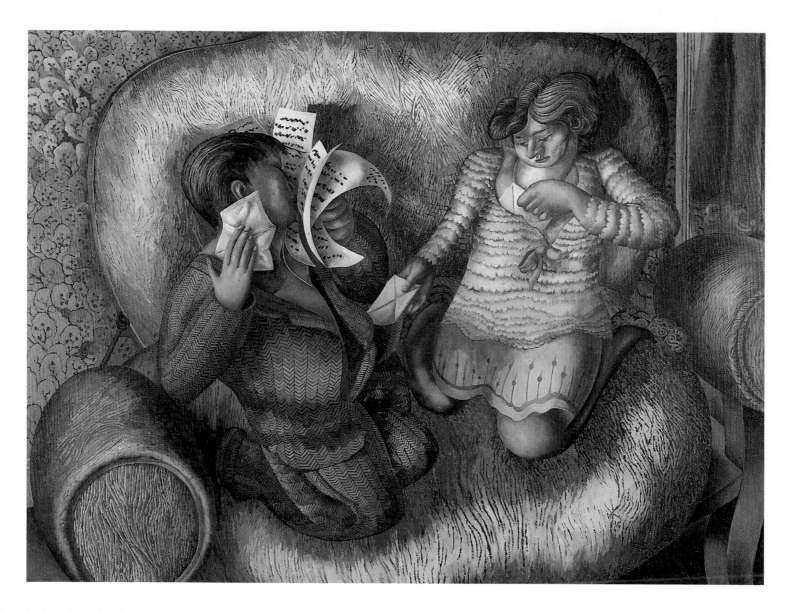

86 *Love Letters* (1950).
Oil on canvas, 86.4 × 116.8 cm (34 × 46 in).
Thyssen-Bornemisza Collection, Lugano

87 *Rock Roses, Old Lodge, Taplow*
(1957). Oil on canvas, 61 × 50.8 cm
(24 × 20 in). Private collection

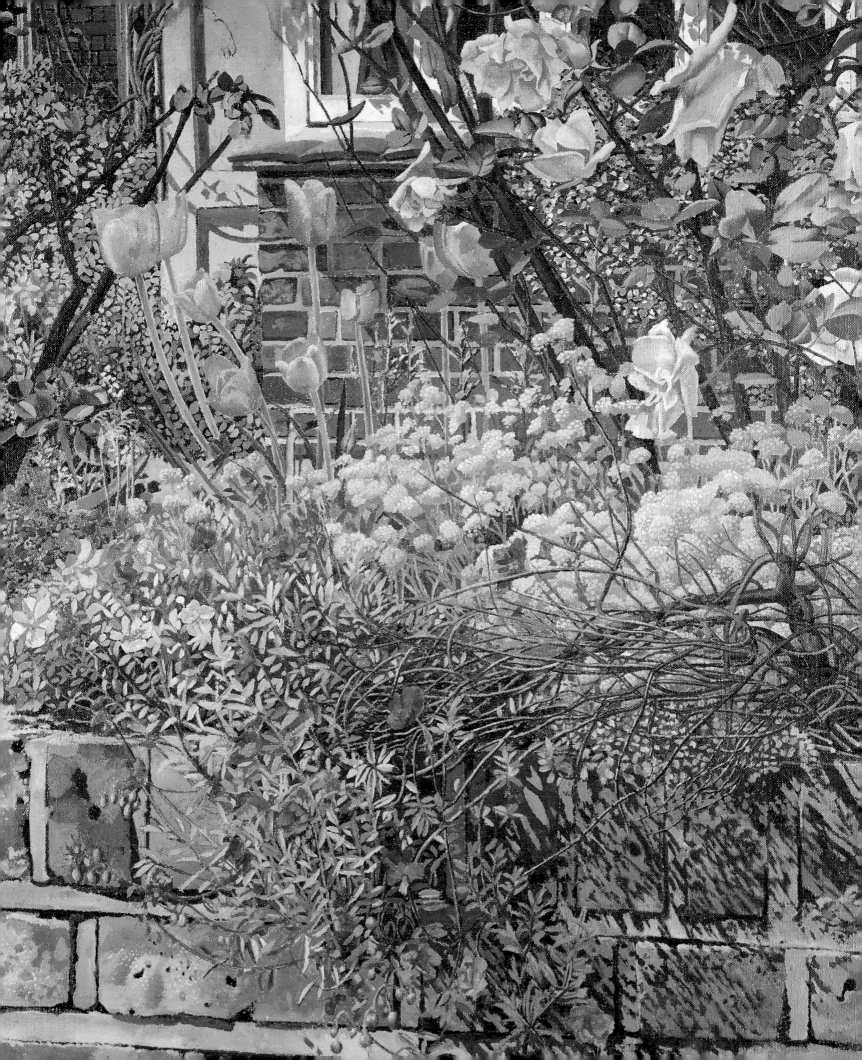

Fame 7

By 1950 the star of Spencer's reputation seemed to be once more in the ascendant. The list of honours accumulated steadily, from the C.B.E. he received in that year, together with reinstatement in the Royal Academy, through honorary degrees, promotion at home by the British Broadcasting Corporation and abroad by the British Council, to a retrospective at the Tate Gallery in 1955 and the final accolade of a knighthood, bestowed in 1958. The whiff of controversy which surrounded him did nothing to deter the goddess Fortune who smiled, like his proud neighbours in Berkshire, at those eccentricities which served merely to confirm his wayward genius. As his brother Gilbert Spencer noted, the public discovered 'that as well as being a painter, he was a personality.'[1] The unassuming demeanour became a cherished hallmark, as much a part of his public persona as it was for the contemporary film star Charlie Chaplin.

Press photographers flocked to Cookham to follow the ageing painter as he set out early in the morning, shabbily dressed, to push his painting cart (an old perambulator laden with canvas, paints and brushes) down the High Street towards some chosen site [pl. 1]. He encouraged the attention. 'Yesterday, I was on my pitch in the Church-yard at 7–10 and it was very cold,' he wrote on 3 August 1958 to Dame Mary Cartwright, the subject of one of the finest of his late portraits. Thanks to both family and friends, he was able to settle once again in Cookham, and it provided him with countless opportunities for landscape painting [pl. 90]. It also rekindled the old flame and led to a remarkable succession of paintings he did not live to complete.

Spencer's postwar reputation raises an interesting question about artistic recognition in the present century. When *The Resurrection: Port Glasgow* was shown at the Royal Academy in 1950, it became something of a *cause célèbre*, especially after (Sir) Winston Churchill was heard to quip that 'if that is the Resurrection, then give me eternal sleep.'[2] It was acquired, like its predecessor of 1926, by the trustees of the Chantrey Bequest and presented to the Tate Gallery. Yet as the then Director, (Sir) John Rothenstein, pointed out, its accession to the national collection was not unopposed. What concerned him, writing in 1955, was the fact that 'the artists whose work I most admired and whose opinions I generally respected were among its severest critics.'[3] Just when Spencer's art became accessible to the point of popularity, his standing among his peers dropped sharply. It was a fate he shared with a number of contemporaries, William Roberts and Edward Burra for example, both figurative painters whose work appeared to be distinctly *passé* to the younger generation for whom the St Ives group pointed towards the new art, based upon internationally accepted theories of abstraction. Unlike his subject, Rothenstein lived to see the tables turned thirty years later, when the figure returned with a freshly distorted vengeance to reclaim Spencer as a kind of Old Testament prophet for the avant-garde of the 1980s.

88 *Bathing Pool Dogs* (1957). Oil on canvas, 90 × 62.5 cm (36 × 27 in). Private collection

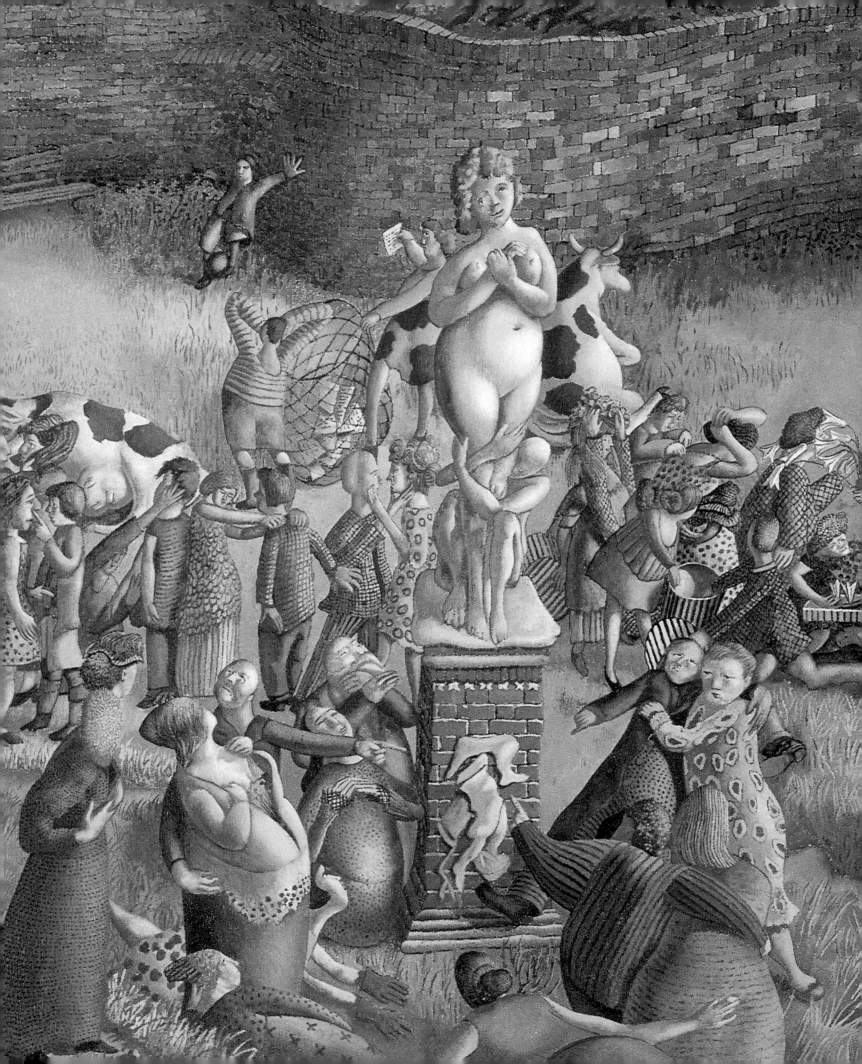

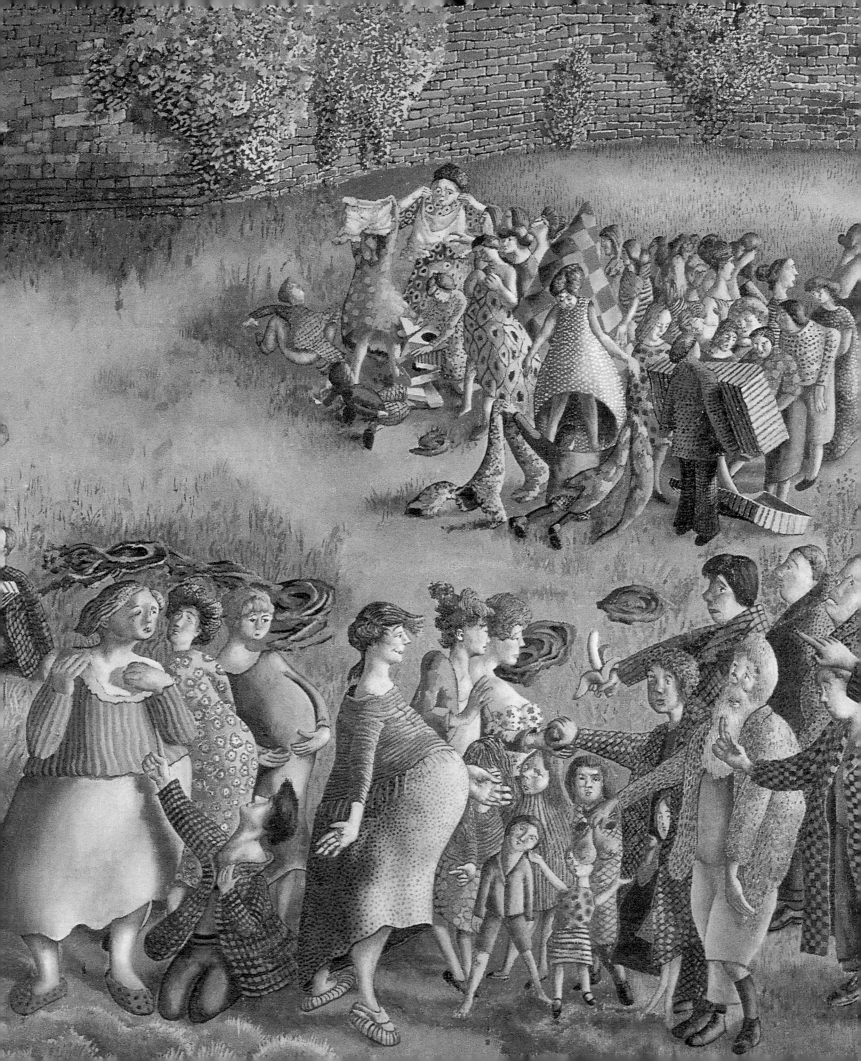

For the painter himself, the year 1950 held further significance. In November Hilda Spencer died of cancer. From one of the unposted letters he had written to her twenty years earlier, on 22 May 1930, her former husband salvaged an imaginary sketch of the two of them, firmly embedded in the upholstery of an old sofa, exchanging their affection by means of *Love Letters* [pl. 86].[4] The painting of 1950 follows the drawing faithfully; in both, Spencer portrayed himself kissing his sheaf of script while his wife tucked envelopes with one hand into his pocket and with the other into her bosom. With this ritual of mutual affection, he was able to sustain the myth of communication for the rest of his life. His correspondence with Hilda continued, one-sided, until his own death nine years later. Separated as they had been for the better part of twenty years before she died, Spencer contrived to regard their parting as temporary, and to effect through his painting that final reconciliation which was, for him, a fundamental article of faith. He revived his plans for the Church-house in the spirit of his long-held conviction that 'my desire to paint is caused by my being unable

89 PREVIOUS PAGE: *Love on the Moor*, detail of plate 95

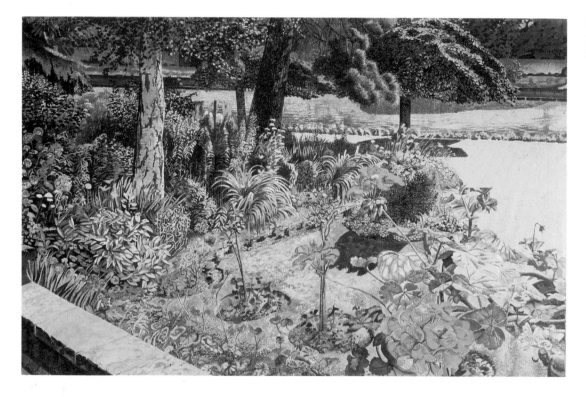

90 *The Thames at Chauntry Court* (1951). Oil on canvas, 50 × 75.5 cm (20 × 30 in). Private collection

– or being incapable – of fulfilling my desires in life itself.'[5] In 1953 he painted for it *The Marriage at Cana: Bride and Bridegroom* [pl. 92] as an undisguised re-enactment of his first marriage and *Hilda Welcomed* (Art Gallery of South Australia, Adelaide) in anticipation of their reunion on the Last Day. Both canvases are thinly painted over detailed drawings, squared up, like so many of Spencer's late paintings, from earlier, autobiographical sketches. His prodigious visual memory was undimmed. The painting of *The Farm Gate* (Royal Academy of Arts) which he presented to the Royal Academy as his Diploma picture in 1950 was based upon a recollection from his Cookham childhood of the farm across the road from Fernlea. Like his painting of the Beaufort Hospital gates in the Sandham Memorial Chapel, those of Ovey's Farm are shown from above, from the high vantage point which

the diminutive painter enjoyed first as a child, as he looked down from his bedroom window. In 1946 he recalled the incident in the minute detail of one of his scrapbook drawings (dated 16 June), before transferring it to canvas four years later. Similarly, *Hilda and I at Burghclere* [pl. 91] is based upon an intermediate drawing which returns to the theme of those Domestic Scenes he had created twenty years earlier in his attempt to come to terms with his broken marriage.

By far the most ambitious of Spencer's memorials to Hilda is the canvas he began in 1937, abandoned in the studio at Lindworth a year later, rescued in 1945 and completed in 1955. In *Love on the Moor* [pls. 89 and 95] Spencer raised a statue of Hilda as the Goddess of Love upon the most sacred of all turf: Cookham Moor. From her vantage point the plump and modest modern Venus smiles with shy approval upon the human landscape. Entwined beneath her thighs, the dwarfed male worshipper represents Everyman Spencer, a diminutive Pygmalion groping to establish life in the stone. Behind the statue, painted with even fuller curves and fleshy roundness, lies a spotted cow, its horned

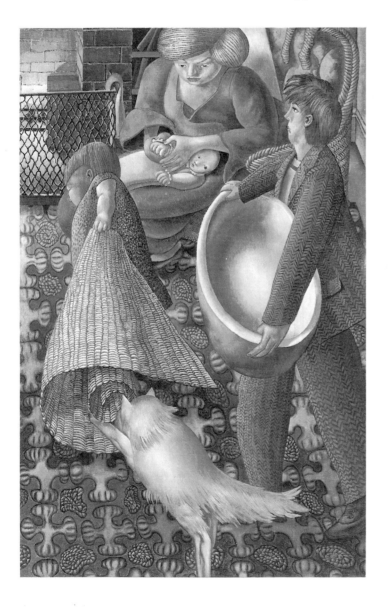

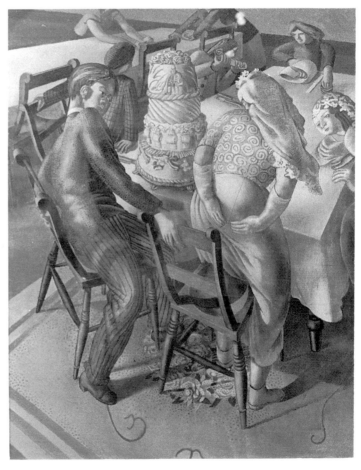

92 *The Marriage at Cana: Bride and Bridegroom* (1953). Oil on canvas, 66 × 50.1 cm (26 × 20 in). Glynn Vivian Art Gallery and Museum, Swansea

91 *Hilda and I at Burghclere* (1955). Oil on canvas, 76.2 × 50.8 cm (30 × 20 in). Private collection

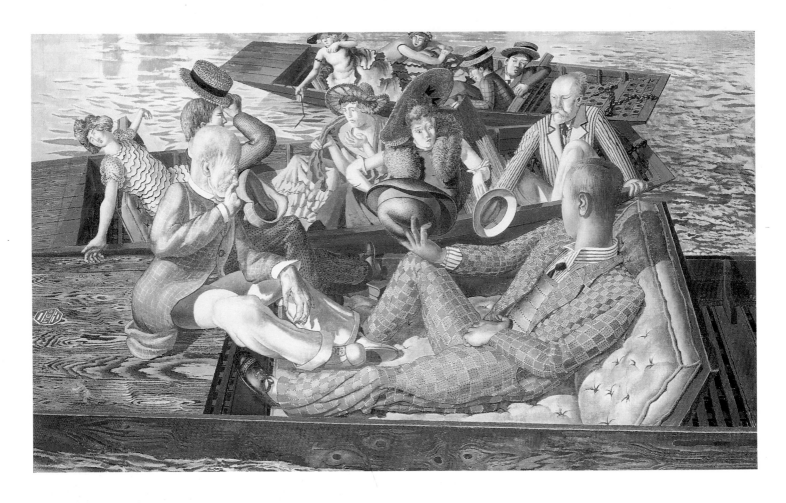

93 *Christ Preaching at Cookham Regatta: Punts Meeting* (1953).
Oil on canvas, 79 × 129.5 cm (31 × 51 in).
Private collection

94 *Christ Preaching at Cookham Regatta:*
Dinner on the Hotel Lawn, detail (1956–57).
Oil on canvas, 95 × 136 cm (37⅜ × 53½ in).
Tate Gallery, London

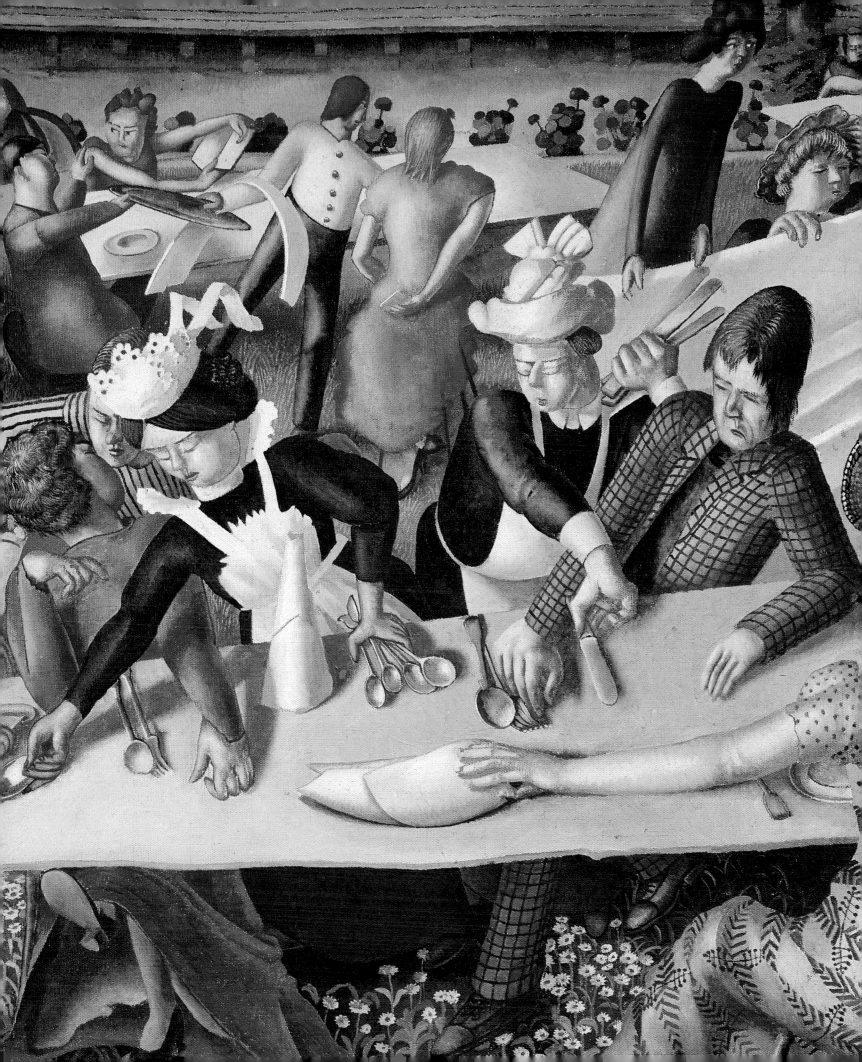

head in profile to the right, while to the left, with deliberate ambiguity, a woman stands, her spotted dress taking up the pattern of the Friesian's hide. It is a visual pun which sets the pace for the rest of the vast canvas as a fertile playground for the pleasures of the senses. Humour plays a vital part, as couples embrace and crowds converge to indulge in the rituals of love-making. They smell flowers, exchange presents and try on new clothes (a reference to the expensive furs and hats Spencer lavished on Patricia during their courtship). The woman in the spotted dress rescues what is presumably another of Spencer's love letters from a wire wastepaper basket. In the foreground the bulging profile of an expectant mother invites the admiration of men and children of all ages, while a young man offers a peeled banana to one of her companions.

95 *Love on the Moor* (1937–55). Oil on canvas, 79.1 × 310.2 cm (31⅛ × 122⅛ in). Fitzwilliam Museum, Cambridge

In 1950 Spencer was threatened with prosecution when the former President of the Royal Academy, Sir Alfred Munnings, instigated police enquiries on the basis of several drawings he claimed were obscene. 'I have always wanted to express the joy of sex feelings for Hilda,' Spencer wrote to their daughter Unity in 1957. 'I don't always like symbols, but because of the law must have recourse to them.'[6] In *Love on the Moor*, the symbolism itself requires little explanation, but by sheer pictorial inventiveness Spencer succeeded in restating his familiar theme with extraordinary freshness and delight. The carnival atmosphere embraces all of the figures in that superabundance of affection which Hilda inspired as the resident deity of Cookham.

When John Rothenstein referred to Spencer as 'more of a village Rowlandson than a village Giotto,'[7] he touched upon an aspect of the painter's genius which deserves greater emphasis. An element of caricature played an important part in the effectiveness of the Beatitude Couples painted by Spencer in 1937–38. The anecdote he told at the time[8] implies that he thought of the joke as being, in part at least, against himself. The drawing and unfinished painting of *Me and Hilda, Downshire Hill* (private collection) confirms the point that he did not exempt himself from an essentially satirical view of human nature, a view which managed to be both sharp and generous in its delineation of the species. This attitude is one which links Spencer to a tradition in British art at least as old as Hogarth. In looking at his treatment of human physiognomy, comparisons with that graphic tradition are unavoidable. The figures in *The Marriage at Cana: Bride and Bridegroom* [pl. 92] are bounded by the kind of sure lines and simple contours that Robert Dighton (1752–1814) employed in such drawings as *A Windy Day* (London, Victoria and Albert Museum). In a retrospect of Spencer's oeuvre, it seems possible that he may have explored such visual sources as early as 1930, prior to his design

96 *Christ Preaching at Cookham Regatta: Conversation between Punts* (1955). Oil on canvas, 106.7 × 91.5 cm (43 × 36 in). Private collection

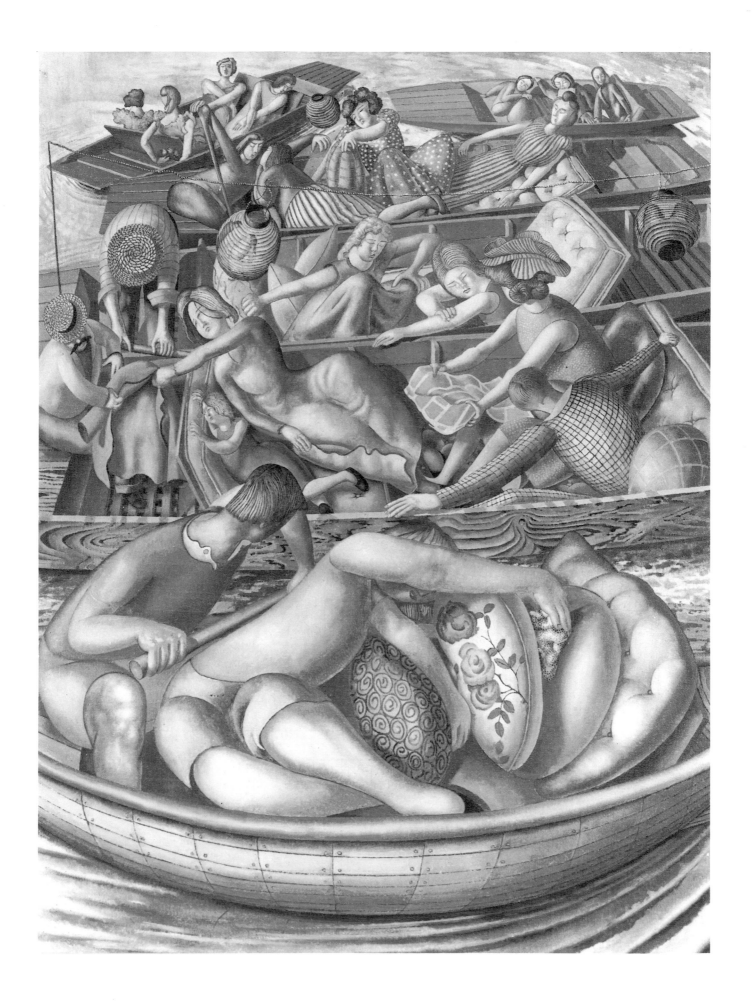

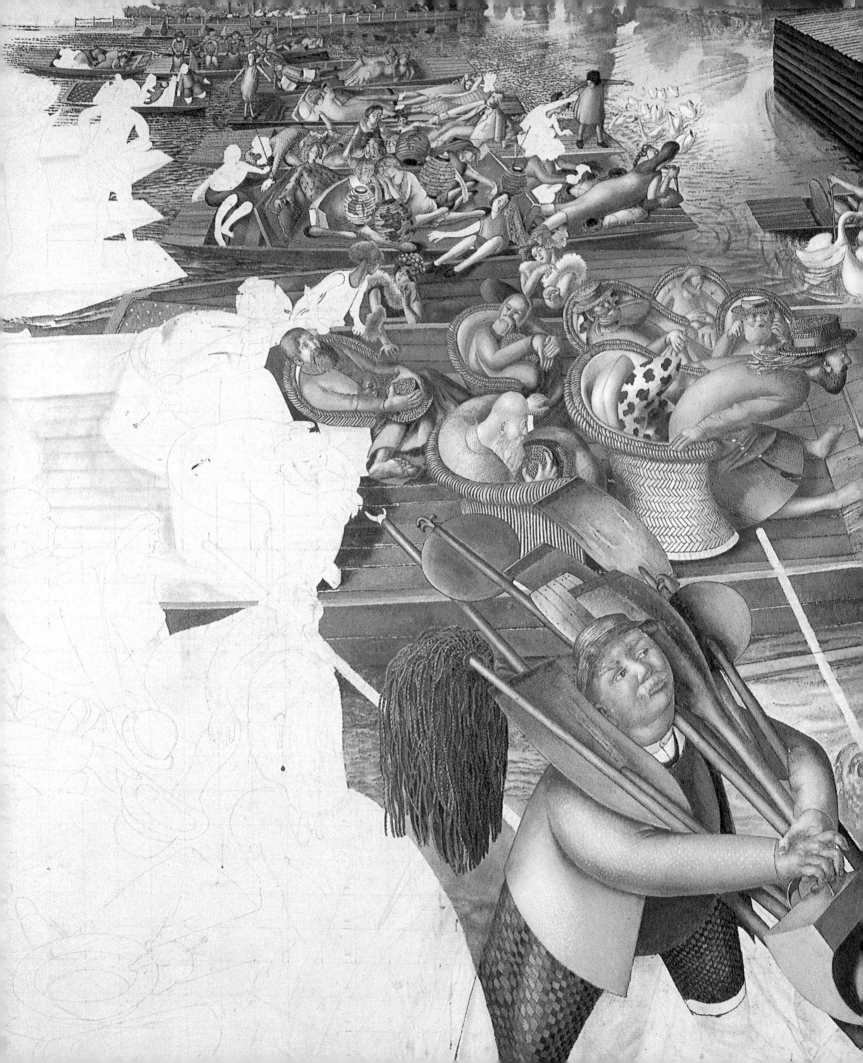

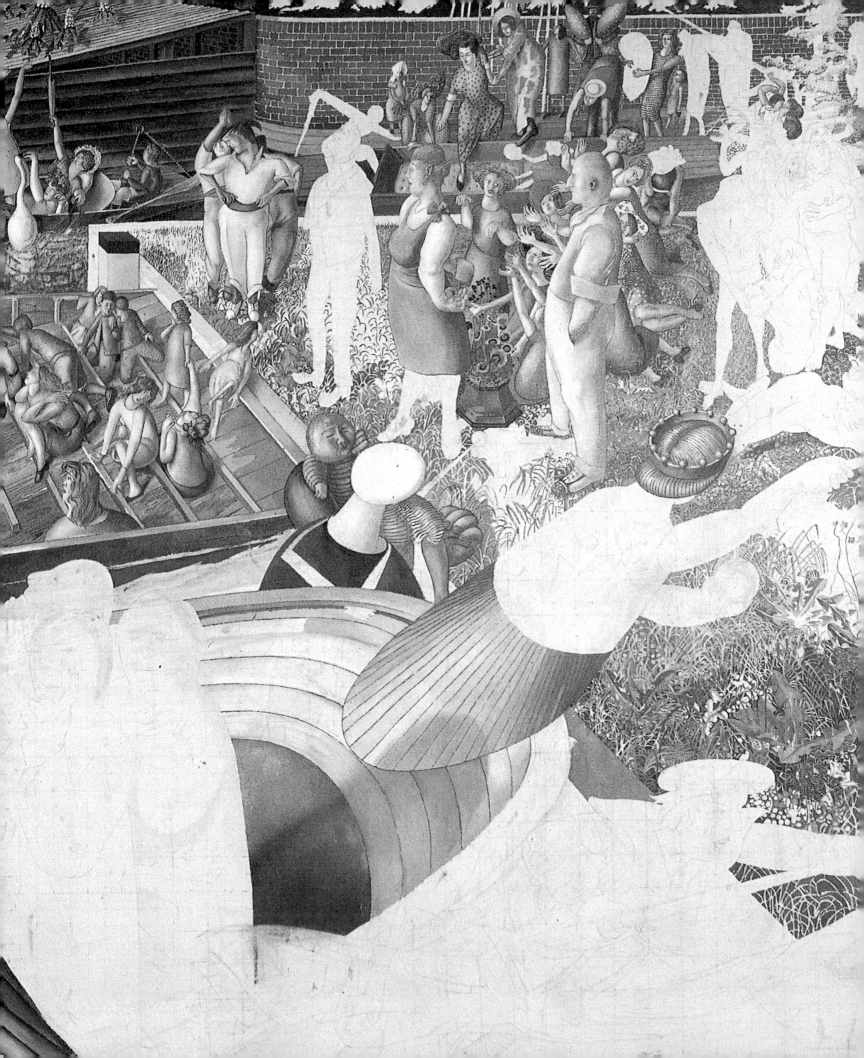

of *Sarah Tubb and the Heavenly Visitors* [pl. 50]. At all events, Dighton's distinctive repertory of facial expressions finds unmistakable echoes among the witnesses to *The Resurrection: Port Glasgow* [pl. 85] and the celebrants of *Love on the Moor*. In the last there are more recent echoes also of the contributors to *Punch* during Spencer's lifetime, from H. M. Bateman in the early years of the twentieth century to David Langdon and Hollowood in the 1950s. To trace such affinities is not to diminish Spencer's achievement; his goal remained the incurably ambitious one of human salvation. It was for him a source of strength to draw upon a graphic tradition in which beauty remained the abstract partner of concrete truth and faith in human nature could only be sustained by coming to terms with all of its individually wonderful imperfections.

In 1944 Spencer wrote to Hilda about an idea he had for a painting of 'Christ preaching from a boat. . . . The place is Cookham bridge. I don't know yet whether he is a week-end guest sort of person or me-out-painting or not so much human as connected with the sedgy bank of the stream. But it will come.'⁹ It began to, in earnest, in 1952–53, when Spencer drew out his designs, more than sixty of them, in red chalk. In bringing Christ back to Cookham, he was acknowledging the end of his own exile. From 1945 onwards, he lived at Cliveden View, a small modern house on the outskirts of the village which belonged to his brother Percy. It was aptly named after the country seat of the Astor family, important patrons of Spencer's last years, whose country house was visible in the wooded distance across the River Thames. He was to live there until 1959 when he was enabled to return for the last few months of his life to Fernlea. But it was from Cliveden View that Spencer's final tribute to Cookham took shape.

Christ Preaching at Cookham Regatta was destined, in his mind at least, for the river-aisle of the Church–house. At its centre he planned the canvas, more than seventeen feet long, on which he was at work at the time of his death [pl. 97]. It derives, together with all of the scheme's component parts, from recollections of a Cookham which had disappeared by the middle of the twentieth century. Like the prophecies of Blake and the rural dreams of Palmer, its touchstone is nostalgia, buried in the past. As Gilbert Spencer recalled, 'the regattas we knew were Edwardian. . . . The village would be gay, with flower boxes in many of the windows, and flags and bunting, and people might be seen concealing fairy lights among the flowers and hanging out Chinese lanterns for the illuminations later on. . . . The Regatta always emphasised class distinctions; there were those on the river and those on the bank. Those on the river collected themselves in groups, according to rank, and floated about together holding on to one another's boats and punts, looking like gay little floating islands.'¹⁰ The description fits *Punts Meeting* [pl. 93] in which a group of well-to-do revellers lounge, arrested from their pleasures by the sermon on the Thames. In the *Conversation between Punts* [pl. 96] the comparison between the parallel craft and the 'grown-ups in prams' of the Port Glasgow Resurrection is inescapable. Here the Chinese lanterns are in evidence, just as the flower-boxes appear in *Dinner on the Hotel Lawn* [pl. 94], a further reflection of those class distinctions which separated the Spencer boys from the more fashionable members of local society on Regatta Day. From their vantage point on the bridge, they could look down on the scene at the Ferry Hotel much as they were used to peering from the upstairs windows at Fernlea. It was 'an outdoor social occasion in which . . . we were able to take part almost anonymously.'¹¹

Gilbert Spencer's words recall the way in which his brother depicted the two of them as casual witnesses to *The Betrayal* when he staged that episode from the life of Christ in the alley behind

97 PREVIOUS PAGES: *Christ Preaching at Cookham Regatta* (unfinished). Oil on canvas, 205.7 × 535.9 cm (81½ × 211 in). Private collection (on loan to the Stanley Spencer Gallery, Cookham)